A–Z

OF

ABERGAVENNY

PLACES – PEOPLE – HISTORY

Tim Butters

AMBERLEY

Acknowledgements

A big thank you to Udo Schultz, Malcolm Lewis, Michael Woodward, Andy Sherwill, Tim Evans, David Bowen, Dennis Eldridge, the *Abergavenny Chronicle*, Forgotten Abergavenny and everyone else for their superb images, which, as always, speak a thousand words.

First published 2018

Amberley Publishing
The Hill, Stroud, Gloucestershire, GL5 4EP
www.amberley-books.com

Copyright © Tim Butters, 2018

The right of Tim Butters to be identified as
the Author of this work has been asserted in
accordance with the Copyrights, Designs and
Patents Act 1988.

ISBN 978 1 4456 8294 5 (print)
ISBN 978 1 4456 8295 2 (ebook)

British Library Cataloguing in Publication Data.
A catalogue record for this book is available
from the British Library.

Origination by Amberley Publishing.
Printed in Great Britain.

Contents

Introduction 4

Avenue Road – Anyone for Cricket? 5

Bailey Park – A Munificent Gift 9

Coopers – When Business
was Booming 13

The Deri – One of Abergavenny's
Seven Hills 16

Eisteddfod – A Slight Return 21

Foxhunter – A Horse Without Equal 25

The Gavenny – A River that
Flooded a Town 27

Hidden Tunnels – The Mystery of
Abergavenny's Underground
Network 31

Father Ignaitus – A Monk on a Mission 35

Joseph Garcia – The Spanish Butcher 37

The King of Abergavenny –
Elvis Davies 43

Linda Vista – A Beautiful View 47

3rd Mons – The Horror and the
Sacrifice 50

Nevill Hall – From Country Manor to
Hospital 54

Ostringen – A Bond Born on
the Terraces 57

Pen-y-Pound – They Call Them the
Thursdays 61

Quaint Abergavenny – The Marvels of
Modernisation 65

Racetracks and Riots 70

Swimming Pool – Paradise Lost 74

Alison Todd – A Hat for
Every Occasion 78

The Usk – Old Man River 81

Victorian Abergavenny 83

The Workhouse – An Abergavenny
Institution 85

X Division – The Abergavenny
Underclass 88

Bryn Yemm – The Boy from
Tudor Street 91

Zachariah Wheatley – The Mayoral
Maverick 93

Introduction

There are only twenty-six letters in the alphabet, but those linguistic foundation stones are more than enough to create an infinite world of words, sentences and paragraphs, swarming with tales without end and horizons without sunsets. Which brings us nicely to *A–Z of Abergavenny*. Obviously there are more than twenty-six things in the town – often referred to as the 'Gateway to Wales' – but cutting the wheat from the chaff and choosing what goes in and what stays out when painting a captivating and comprehensive picture of old mother Aber is no easy task.

When writing a book such as this, the last thing you want to do is repeat ad nauseam that which already sits in awful abundance on bookshelves and in the digital wastelands. There are plenty of books that already describe in great detail the history of Abergavenny Castle, its churches, institutes and industries. Likewise, the lesser-known and somewhat unsavoury aspects of the town have already been covered in one of my previous books: *Secret Abergavenny*. So, where does that leave us? In a very enviable position as it happens. When striving to document something established from a new angle and a new perspective you're free to wander aimlessly off the beaten track, down the wayward path and through a gate clearly labelled 'notoriety' to journey into a world of hidden truths, barely formed half-rumours and factual evidence as fragile as a whisper on the wind.

Roald Dahl once said, 'The greatest secrets are always hidden in the most unlikely places.' So, with this in mind, let's venture back into the past with nothing but a pickaxe to chip away at the rock of ages and a rope to return us to the present, safe and sane.

All aboard! It's time to pull up the anchor, break out the rum and throw both caution and sails to the four winds as we chart a course from A to Z in the sometimes calm, sometimes troubled, but perpetually deep and colourful waters of a small market town in Wales that's always punched well above its weight.

Make hay while the sun shines, or take a stroll down Castle Meadows instead.

A

Avenue Road – Anyone for Cricket?

Not far from the hustle and bustle, and grunts and groans of Abergavenny's commercial hub – also known by the locals as 'the town' – we have the salubrious surroundings and tranquil delights of Avenue Road.

Also known as 'posh Abergavenny', Avenue Road is a fine place to wander aimlessly and marvel at some thrilling examples of Georgian, Victorian, and Edwardian architecture. As a postcode, Avenue Road is well out of the price range of most Abergavenny natives, but it remains a popular choice of destination for sporting enthusiasts. Both cricket and bowls have been played in this little northern corner of the town for over a century, and on a balmy summer's afternoon, the sound of leather hitting willow can conspire with a well-made gin and tonic to make a man fall in love with this picturesque little paradise. Rewind the clock 100 years and a bunch of suffragettes begged to differ.

The year was 1913 and the National Eisteddfod roadshow had just rolled into Abergavenny. Some big movers and shakers in the Parliament of the time, such as David Lloyd George and Reginald McKenna, were present to shake hands and make grand speeches. This made Abergavenny a prime target for the 'petticoat bandits', as the suffragettes were oft described. Just a month earlier, Emily Davison had thrown

Avenue Road bathed in the shadow of the Deri.

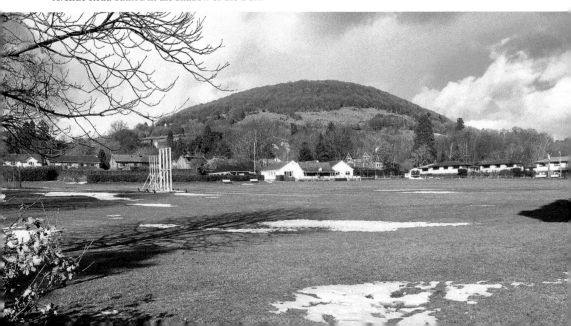

herself in front of the king's horse at the Epsom Derby. As a gesture it caught the world's attention, but it also cost Emily her life. The scene was set for a similar 'scandal' in Abergavenny. And the Avenue Road cricket ground was selected as the stage of choice.

Under cover of darkness, a group of political arsonists set fire to the Avenue Road Cricket Pavilion while the oblivious groundsman was sleeping inside. Fortunately, the fire was spotted early and quelled before it really took root. The groundsman was also unhurt. The petticoat bandits had littered the scene with suffragette literature, emblazoned with headlines such as 'Votes for Women' and 'If Pankhurst dies, Lloyd George will be a murderer'. The suffragettes carried out another arsonist attack in Abergavenny on a nearby farm, which amounted to £140 of damage. In terms of publicity, it was priceless. The soaring voices of the Eisteddfod and the pyromaniac antics of the suffragettes turned the national spotlight on Abergavenny in that dizzy and distant summer of 1913.

Over the decades, as the home of Abergavenny Cricket Club, also known as the Beavers, Avenue Road has been the breeding ground of many a first-class cricketeer. Glamorgan CC stalwarts Mike Powell and Mark Wallace both began their first tentative steps on the crease there. The club has its own legends in the likes of J. R. (John Reginald) Jacob – the club's youngest, eldest and longest-serving captain (a total of eighteen years). And then there was Dr A. L. Tatham, who knocked out century after century with his stroke play and thrilling style. G. N. (Guy) O'Daly was another born crowd-pleaser. In 1938, when Glamorgan XI visited Avenue Road for the first time, O'Daly took five wickets against them.

You gotta bowl with it – the Beavers in action on their home turf.

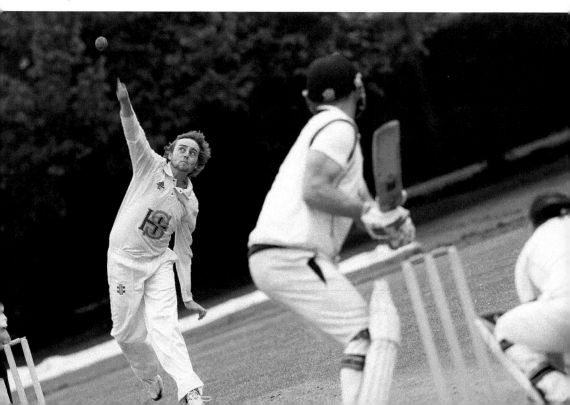

Glamorgan county championship matches became a common fixture at Avenue Road over the years, as did famous visitors such as Prince Charles and Ian Botham, who have all enjoyed a glass of Pimms or can of Stella at the picturesque venue. Of course, one of cricket history's most famous incidents involves perhaps Avenue Road's most famous son – Malcolm Nash.

When West Indian legend Gary Sobers hit Abergavenny man and Glamorgan CC player Malcolm Nash for a historic 6 sixes off 1 over at Swansea in 1968, cricket's Everest was finally conquered. It was a record that could never be broken; equalled three times since but not beaten – you can't get better than six of the best!

Alongside cricket, Avenue Road is, of course, home to a healthy and historic bowls club. Bowls, alongside archery, is said to be the oldest of British outdoor pastimes. Yet, in its early years this most refined of games was subject to repressive legislation because the frequent association of bowling greens with taverns encouraged the association of gamesters and others of dissolute character. It was Great Britain's taverns and inns that saw the game flourish, as the greens were often seen as a pulling point for thirsty punters. Abergavenny, of course, was no exception. There used to be a piece of land behind the Great Western Hotel on which a bowling green was laid out. It was improved and enlarged by the hotelier Mr James Howard, at his own expense, and because of its location the club was sometimes called Little Skirrid Green Club.

The *Abergavenny Chronicle*'s founder, Edwin Morgan, was the first president of the club after it was officially reorganised and recognised as the Abergavenny Bowls Club in 1878. In 1882, he handed over the office to F. C. Hanbury Williams, while stating 'new blood was now needed to guide the club'.

Victorian hipsters lining up on Abergavenny's green of dreams in 1874.

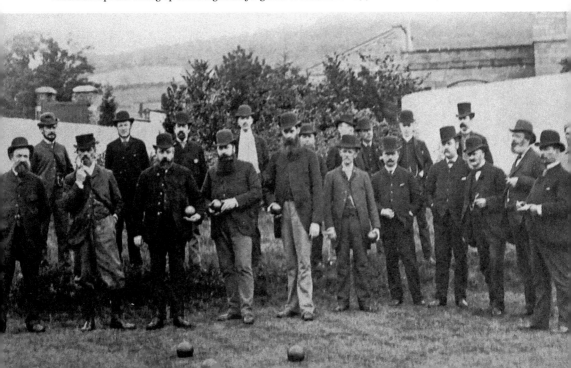

In the late 1890s interest in the club appeared to wane and many believe 1895 was the year in which the club ceased to meet at the Great Western Hotel ground. The decline of interest in the game could have been the lack of younger bowlers coming forward, but also because in 1896 the Abergavenny Cricket Club moved to its permanent home at Avenue Road and offered a rival attraction for those interested in summer games and an associated social life. Yet help was at hand when the cricket club offered the bowling club a chance to re-establish itself at Avenue Road, which, of course, it did.

There used to be a popular shop in town called Claude Stephens newsagent – a name instantly familiar to many acquainted with Abergavenny Bowls Club – as Claude was one of the four local bowlers who represented Wales at the 1962 Empire Games held in Perth, Australia. Alongside Claude, the rest of the red-blazered Abergavenny men consisted of Albert Evans, Tom Griffiths and Lynn Probert. It was the first time in history all four players were chosen from the same club. While the four bowlers who had previously won the 1960 Welsh Bowling Association Rinks Competition won no medals, they were placed fourth and made a magnificent impression, which put Abergavenny on the worldwide bowling map and added another proud chapter to the rich and colourful history of Avenue Road.

B

Bailey Park – A Munificent Gift

Nestled in the heart of Abergavenny, Bailey Park is viewed by many as the jewel in the town's crown. Its leafy environs have been a temporary home to steam rallies, carnivals, music festivals, cycling races, tanks and even legendary gunslinger Buffalo Bill, who brought his Wild West show to this sleepy market town way back when.

It's long been a stage of sporting endeavour and a popular location of choice for dog walkers and daytime drinkers. Bailey Park marked its 144rd anniversary this year, and like an aging starlet who's over the hill and on the long inevitable slide into ruin, many would say the old place is but a shadow of its former past. In fact, it's safe to say the planner's dream has gone wrong. It wasn't envisaged this way back in the heady days of 1884 when the vision of a green space and recreational area for all first became a reality.

Under the headline 'The Munificent gift Of Mr Crawshay Bailey', the *Abergavenny Chronicle* reported how Mr Edwin Tucker, on behalf of Mr Bailey's Park Committee, read a rough draft to the town council for 'the government and orderly keeping of the park'.

As in the case of most things, there was a big difference between now and then, and the running of the park was no exception. Whereas nowadays we just have poor quality CCTV and public vigilance to protect old mother Bailey from the vicious whim

Ice cold – a snowman chilling in Bailey Park.

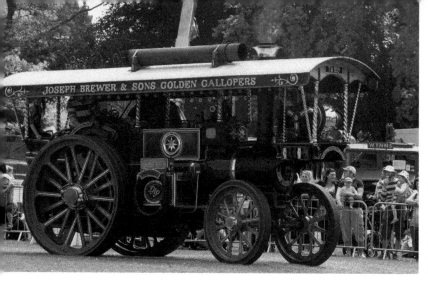

Thousands of punters flock to Bailey Park on May bank holiday to let off steam at the annual gathering of big oily engines at the Abergavenny Steam Rally.

of the cowardly vandal, Mr Bailey insisted on appointing a park keeper who would control and regulate the grounds around the clock.

Mr Bailey was a hands-on type of guy and insisted that no game – of any nature – be allowed to be played in the park without the club first procuring the necessary licence from a person appointed by his good self.

Naturally, being a ludicrously rich landowner (some 12,248 acres in Wales alone) wasn't without its perks and Bailey reserved the right to let the whole of the park out to anyone and at any time, if he deemed it as beneficial to Abergavenny. Mr Tucker pointed out just how advantageous this would be and for the benefits of any doubting Thomas he explained, 'For instance, should Mr Bailey accept the post of president to the West of England Agricultural Club, he might say to them, "I have a nice ground suitable for your meeting. Come down into our part of the country and I will see the park at your disposal."' And there we have it – the job's a good 'un!

Mr Johnson, who was responsible for the planning and design of Bailey Park, laid out his vision in the following terms:

> Along the side nearest the cattle market a stone wall will be built with an iron railing on the top of it, the remaining portion being enclosed by an ornamental fence of larch with the bark left on it. The principal entrance gates will be from the Hereford-road side, and will be composed of two ornamental gates hung from massive piers, with side gates for the entrance of foot passengers, the central entrance being sufficiently wide to accommodate a four-in-hand with ease. On the left hand a lodge will be erected in the Gothic style. Shrubs will be planted inside the fences, and then a half-mile course will encircle the ground. Inside this will be a bicycle track, football, cricket, and other grounds, an ornamental pond, a grandstand and pavilion, a bandstand, and the necessary offices to make the park as complete as possible.

Then, to much applause, Mr Tucker added that a spot adjoining the Hereford Road side was earmarked by Mr Bailey as a site for a possible swimming bath. Mr Bailey explained he had altered the plan to do away with the lawn tennis ground and said, 'It would not do to mix up the lawn tennis with the football and cricket, and we already have lawn tennis courts at the castle which the tennis players could retain.' It was reported that several members of the council nodded their heads sagely at this wise decision.

The so-called 'people's park' was scheduled to be ready for use by 1 May of that year and the council were agreed that 'it will be a means of perpetuating the memory and transmitting the name of Mr Bailey to distant generations as one of the chief benefactors the town ever had'. Of course, Crawshay still owned the park and called the shots regarding its use – the town were just leasing it – but ten years later that would all change.

After Mr Bailey's shock death in 1887 at the age of forty-six, the park's future was undecided. In 1894, a public meeting was held at the Town Hall to decide the question as to whether the town should purchase the freehold of Bailey Park, so as to secure it as a recreation ground. The board of commissioners agreed that had Mr Bailey lived it would have no doubt been his intention to present the park, which he spent between £2,000 and £3,000 upon, to the people of Abergavenny.

As it stood, the initial twenty-one-year lease had a little more than ten years before it expired and the land would revert to the trustees, which consisted of the Bailey clan and associate partners. The board agreed that the town being deprived of the use of the park would be a terrible thing, especially in light of all the money that had been spent upon it. So the board approached the trustees and asked if they would carry out what they imagined was Mr Bailey's original intention: to give the park to the people without the public having to spend anything – fat chance! The trustees insisted upon a sum of £5,000, over £2,000 more than Mr Bailey had initially spent on the park ten years earlier. Faster than you could say 'philanthropic benefactor', the trustees had almost doubled their investment.

It was a big ask for the Abergavenny ratepayers, but the town's council decided to do what everyone does when they want something they can't afford: they got a loan! The loan was from the Local Government Board and sanctioned for a lengthy period. The council were hopeful that the revenue generated by the park would be sufficient enough to pay it back without the ratepayers having to pay a single penny. It was agreed that the park was to be maintained as a public space and the ratepayers were responsible for its upkeep, whether it paid or not.

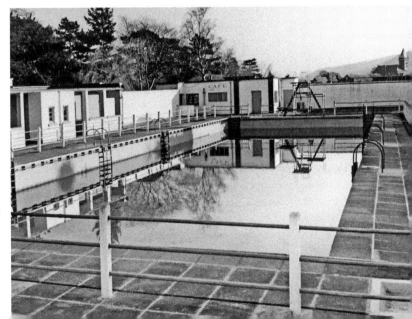

A pooling of resources – Bailey Park Swimming Pool used to be a hugely popular attraction.

Fortress Bailey – the main gates of the old park.

Somewhat mysteriously, Mr Beveridge then asked the question, 'Was there not some privilege to a certain hotel to sell intoxicants in the park?' The chairman replied, 'Mr Crawshay Bailey had a kindly feeling towards the proprietor of a certain hotel, and had accorded the privilege towards him during his occupation of the hotel, but the hotel was now in other hands and no such privilege existed now.'

Mr Beveridge then launched into a lengthy rant about his two great objections in regard to the park. He insisted that the public should only pay for its upkeep on two conditions: no drinking or betting was to be allowed. He then added, 'I have had a great deal to do with young men in the last 16 or 18 years and I always find that sports connected with drink, which brings on betting, are the greatest evils that young men have to contend with.'

What Mr Beveridge would make of the abandoned beer bottles and soiled scratch cards that now litter the rolling greens of Bailey Park on a daily basis is anybody's guess. But we digress. Let's allow the man to finish.

'When we allow young men to drink and gamble without restraint or consideration, we lose them altogether. I could give names of young men lost altogether through these things. I know the majority of this meeting are against me but they ought to listen to me and ban any drinking or gambling in these grounds,' said Mr Beveridge.

Dr S. H. Steel added that he agreed with Mr Beveridge and that the park was a huge advantage to the town, not only for amusement but for the promotion of health. He also thanked him for having the courage to speak his mind at a public meeting, even though his views were not popular.

The Revd S. R. Young also expressed his sympathy with Mr Beveridge and hoped the park would be a blessing and not a curse to the town. He said he would do all he could to help keep the morals of the park right.

And thus ends the tale of how Bailey Park became an integral part of Abergavenny.

Coopers – When Business was Booming

'Working nine to five, what a way to make a living.' And it is harder still nowadays because the jobs just aren't there. Of course, back in the day when employment was plentiful and the fat of the land could feed us all, there was one employer in the Abergavenny area who paid the wages of a lot of local ladies and gents: Coopers Mechanical Joints.

Before Llanfoist turned into an urban sprawl and boasted its very own retail park, Coopers dominated the Llanfoist skyline in much the same sort that the new Morrisons does in Abergavenny. And the story of how it all began, like so many stories, had its genesis in the Second World War.

The Lang Pen Company touched down in this neck of the woods for the sole reason of manufacturing radiators for that most British of planes: the Spitfire. To that end, Llanfoist became the location and a new factory was built. Employment surged as employees did their bit to keep the flag flying for the war effort. In the aftermath of the historical conflict, however, there was no need for Spitfires and the Lang Pen Company vacated the premises and left the factory to stand idle for a period.

The factory was saved from becoming derelict when Coopers Mechanical Joints of Slough picked up the reins and within a year it was employing a workforce of 325.

A blast from the past – Coopers in its heyday.

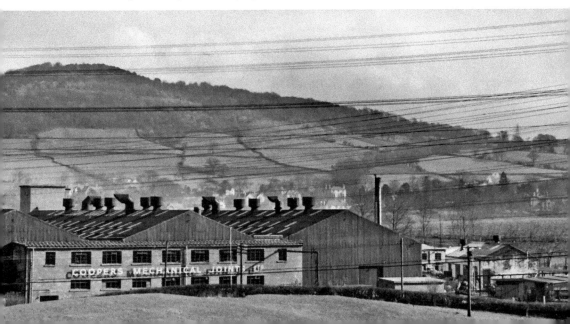

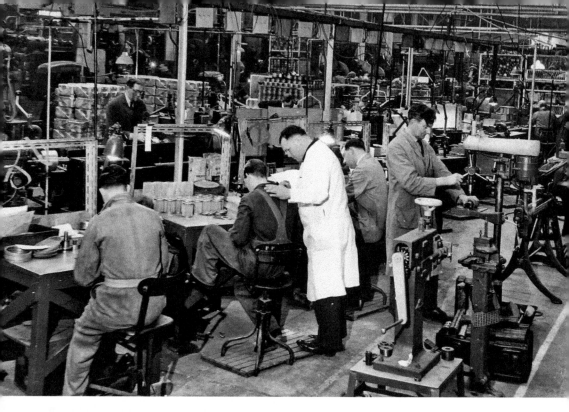

Clocking in and clocking off – life in the factory.

Rapid expansion soon followed and in 1961 significant extensions at the rear and front of the factory took place. By this time business was booming. Coopers' main products were engine components and it soon became a badge of pride that most vehicles on our roads contained a part manufactured at Coopers. It was also a proud boast that all the filters for the London buses came from Coopers.

In 1966, a Manchester firm called Turner & Newall, who knew a good thing when they saw it, bought the Llanfoist company and changed its name to Coopers Filters. Then in 1988 the Italians moved in. The filtration company Fiaam Spa took over and pumped £8 million worth of new machinery and equipment into a major development programme for Coopers – it worked! Things had never been so good.

But as we all know, after every boom comes a bust. In January 2004 Coopers Factory was subjected to the ignoble verdict of the wrecking ball and the bombastic glee of the bulldozer. Newport-based development firm Johnsey Estate Ltd had purchased the site with an eye to building a new housing estate.

Cycling – A Right Runaround

Abergavenny has become something of a Welsh capital for cycling in recent times. The mighty Velothon thunders through the town once a year and the Abergavenny Festival of Cycling continues to delight pint-waving locals who gather in their hordes to watch the two-wheeled heroes rocket around circuits of the town at breakneck speed. The latter, of course, is organised by local man Mr Bill Owen, who in 2016 was awarded an MBE for over fifty years' service to cycling in Wales. Owen, who has also been inducted into the British Cycling Hall of Fame, said of the honour:

It was a very pleasant and humbling surprise. My whole life has been overcoming adversaries, none more so than in my sport of cycling. Nothing is more satisfying in life than to make things happen especially as cycling has not always been regarded as cool.

Being part of British Cycling during its mammoth rise in popularity and its international sporting performance is something to look back with a sense of pride.

Abergavenny's finest cycling export is, of course, Olympian Becky James, who shocked the cycling world in 2017 – a mere year after her silver medal haul at the Rio Olympics – when she announced she was giving up the bike to concentrate on her other passion: baking! 'I have had time to think about my future and have decided to retire from international track sprint racing,' revealed the twenty-five-year-old James.

Despite having a career that has been plagued by injuries, health scares and setbacks, the tenacious youngster has always kept her head up and never appeared to be wanting in the self-belief department.

In Rio 2016, James picked up not one, but two silver medals in an Olympic campaign that was a testament to true grit and the will to overcome. It was a hell of a stage from which to bow out from.

The Quicksilver Queen Becky James.

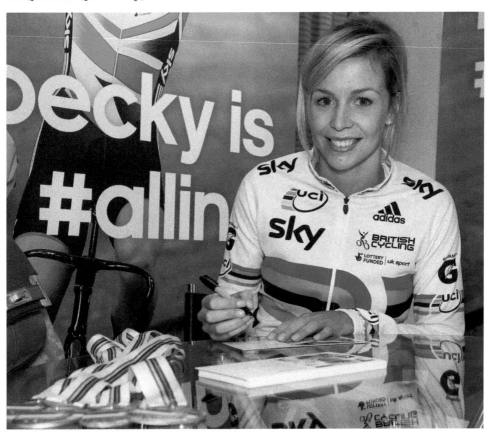

The Deri – One of Abergavenny's Seven Hills

Hillwalking is just the tonic for lifting a person's spirits and putting them in an elevated frame of mind as they marvel at the sublime beauty found in nature's high and lonely places.

Abergavenny is spoilt for choice when it comes to hills. Like Rome, the little market town is surrounded by seven of them. From the brooding majesty of the Blorenge to the stately splendour of the Sugar-Loaf, the impish charm of the Deri and the mystical aloofness of Skirrid Fawr, there's a sanctuary for soul and a dizzying degree of airy abandon to be found in every direction you look in Abergavenny. There's also rare delight to be found in the Little Skirrid, the Rholben and Llanwenarth Breast, but it's the big four that are most native's and tourists' top tumps, and there's a wealth of reasons why.

Take the Deri, for example: it's a cheeky little mount with a sunny disposition and gentle flanks, which even the laziest of walkers will not find too challenging. It's often described as the 'Magical Mountain' because of the otherworldly woodland leading to its summit, but also because in late autumn it is abundant with a bumper crop of mood-enhancing mushrooms. The Deri is always a rewarding hill to climb and one to lounge idly upon, especially on a warm spring evening when the birds are full of

An enchanting walkway leading to the 'magical mountain'.

The Skirrid transformed into a wintery wonderland.

sweet song and the air is heavy with promise and the intoxicating perfume of a warm southern breeze.

In 2016, a few days before the National Eisteddfod, the delightful Deri caught more than just a roving rambler's wandering eye, it captured the attention of the entire town after deciding to get a 'tattoo' on its fair flank of a smiling face and the Welsh word for 'welcome' – *croeso*. It was not the first time this chirpy and cheeky Monmouthshire mount has been emblazoned with a smiley face. This universal symbol of unbounded joy has often popped up periodically on the Deri from time to time in a mysterious fashion, and it usually likes to make a show for the big occasion.

Local legend has it that in 1971 Black Sabbath rented a cottage on the Deri to write and rehearse their third album, *Master of Reality*. How much the classic Sabbath song 'Sweet Leaf' was influenced by this little Abergavenny hill we many never know.

Onwards and upwards! Let's hop over to the nearby Skirrid Fawr for a butcher's. Also known as the 'Holy Mountain', or the 'Big Shake,' the Skirrid has a haughty quality, and well it might. Its peculiar and fragmented shape is thought to have derived from an earthquake. Some say the detached part of the mountain drifted 200–300 yards to the west at the time of Jesus Christ's crucifixion. Others say that during the great flood of biblical times, the Skirrid lay underwater. The tale goes that one day when Noah and his animals were sailing through our neck of the woods, the hull of the great ark tore through the hill and left a mark that is visible to this day.

The Skirrid boasts a hearty hike and some commanding views. It is a hill of great character, best enjoyed in the crisp and stillness of a cold December night and beneath the light of a pale winter's moon.

If there's one hill that appears to watch over Abergavenny like a sentient and kindly guardian, it's the Blorenge. Shaped like the throne of some giant king who's long gone wandering, the Blorenge carries many a scar from the Industrial Revolution, but the

The Punchbowl in all its sublime glory.

tram roads have now become popular walkways for those who want to experience the might and majesty of this grand old eminence. The Blorenge bestows upon all those who walk in its shadow a comforting sense of tranquil wonder. To walk up the near-vertical face of this imperial mount is an arduous task, but well worth it. The whole of Abergavenny stretches out beneath its fierce elevation like a toy town, and with burning lungs and legs full of lead the open-minded hillwalker is left with new and startling perspectives on the transitory nature of history and the eternal fortitude of nature.

A gentle wander down the north-east side of the Blorenge will bring you to the otherworldly realm of the Punchbowl. A hollow of holy stillness centred around a small pond of water, the Punchbowl never ceases to take the breath away, especially when the curious rambler accidentally stumbles across it for the first time.

The Punchbowl is a fitting name because this sleepy hollow was once used as a hillside amphitheatre for illegal bare-knuckle fighting, but nowadays it's more of a calm haven for solitary contemplation than a torchlit arena for the grunt and groan of gladiatorial contest.

Leaving the flanks of the Blorenge to re-enter civilization, a soul is always filled with a strange sense of loss for something elusive that was briefly reawakened in the modern mind on those euphoric and ancient heights. The Blorenge is a fine mountain

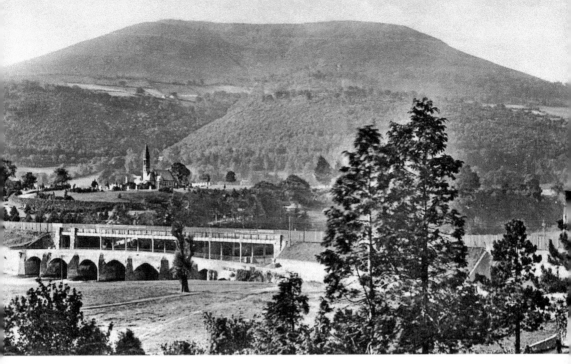

The Blorenge overlooking the Abergavenny of yesteryear.

to experience in any season, but perhaps it is most spectacular when its technicolour reds and golds are shrouded in autumnal mists and the fresh bite of the turning air and twilight's glow conspire to paint its glory on the most apt canvas.

Lastly we turn our attention to the iconic peak that is the Sugar Loaf. Sat in regal repose, this volcanic-like mountain dominates the skyline of Abergavenny. Just 4 metres short of being classified as a mountain, the Loaf is perfect for loafing on during a midsummer's day when the skies are blue, the temperatures are soaring and a strong south-westerly wind buffets around the summit to keep you chilled. When the elements mingle in such a fashion only a fool would ignore the opportunity to enjoy a glass of wine and the panoramic views before the leisurely descent down this languorous mount.

As you descend from the heavens along the well-trodden paths leading from the peak try and visualize how they must have once looked in the early days of the twentieth century, when they were carriageways with a cavalcade of around ninety horses two abreast, drawing carriages of people too lazy or inebriated to walk who wished to take in the mountain air.

Just prior to developing the mountain drives, which dotted the Loaf in decades past, the Abergavenny Public Footpath and Neighbourhood Improvement Society met on 24 February 1931 for an excursion to the Sugar Loaf to plan the proposed routes. The *Chronicle* reported:

> Mr. Wm. Tucker of the Greyhound Hotel, and Mr John Pritchard of the Angel, placed their carriages at the service of the society free of charge. The route taken was up the Old Hereford Road to Triley Court, turning left over the ridge of the Deri. Arriving at the little brook at the base of the Sugar Loaf, Mr. John Prichard confessed to the fact of having brought with him a supply of wines, spirits, biscuits and cheese. A delighted

crowd went at it tooth and nail. The picnic over, the route was again taken up across the foot of the Sugar Loaf, at which altitude the breeze was most exhilarating, over the Llanwenarth Breast, down through the well-wooded vale called St Mary's with its tinkling waterfalls and romantic ferny dells, down by Llwyndu and Chapel Road. A careful inspection was made of the proposed route which will in all probability be selected. The work of making the road will be commenced at once.

Perhaps one of the most fascinating tales about the mighty Loaf is the lost village found on its slopes in 1999. Thick woodland had obscured this hidden Atlantis for nigh on a century. It was discovered during a survey of archaeological sites and experts were at a loss to explain its sudden disappearance and subsequent reappearance. It's believed the settlement of around twenty-five ruined dwellings has its origins at the end of the seventeenth century. Some suggest a rich landowner bestowed the land upon a group of like-minded people who wanted to forge a new community away from the hoi polloi.

Whatever the truth, the village didn't last: by the beginning of the twentieth century the site was deserted. Why? We'll probably never know. Perhaps they simply didn't have a head for heights.

The view from up top – a little rambler makes her way down the Sugar Loaf.

E

Eisteddfod – A Slight Return

In August 2016, things were heating up Abergavenny – well, at least in a metaphorical if not meteorological sense. The temporary structures had been erected, the flags had been hoisted, Only Men Aloud were warming up and the National Eisteddfod was back in town for the first time since 1913.

For seven shimmering days Abergavenny's Castle Meadows became the cultural Mecca of Wales, as humanity's hordes flocked to the Maes and lost themselves in a sea of literature, music, Druidic lore and warm beer. The National Eisteddfod brought over 100,000 visitors and between £6–8 million to the area, and was notable for its new white pavilion that had replaced the traditional pink tent. An Eisteddfod spokesperson said, 'Our traditional pink tent was very iconic, very popular, and very lovely, but the acoustics weren't brilliant, and after all said and done it was just a tent.'

Of course, when it comes to the National Eisteddfod and Abergavenny, one man's name stands head and shoulders above the rest: John David Emerson Owen, better

Sitting pretty – the monument to the 2016 Eisteddfod in Castle Meadows.

All lit up – the Eisteddfod by night.

known as John Owen y Fenni. Until his death in August 1959 at the grand old age of ninety-three, Mr Owen's musical and religious activities and his lively personality were admired not only in Monmouthshire but throughout Wales. He was a brilliant eisteddfodwr, but his enthusiasm took many other forms, including elocution, painting, preaching, drama and sky watching; until he reached his eighties, motoring and cycling could also be added to the list.

Mr Owen would have conducted the National Eisteddfod at Abergavenny in 1913, but at his own request he took the position of platform superintendent in order that Llew Meirion, could act as conductor.

In 1949 he was given the freedom of Abergavenny and a year later awarded the OBE. When he died on 30 December 1960 he was said to have been the 'patron saint of Gwent'.

As is only fitting, the 2016 Eisteddfod was not without its controversy. When it was announced the week before that the Wales football team, who reached the semi-finals of Euro 2016, would not be honoured at the Eisteddfod because not enough of the players spoke Welsh, the reaction to the perceived 'snub' of Chris Coleman's boys was somewhat incendiary. People were lining up in their droves to take a pop at the Eisteddfod or the Gorsedd, or whatever Welsh-speaking tyrant had the brass-necked cheek to ignore the achievement of Gareth Bale and the rest of the men in red.

Plaid AM Bethan Jenkins tweeted, 'I disagree with this decision. This was a golden opportunity for the Eisteddfod to expand its appeal to non-Welsh speaking Welsh people.' Labour AM Ann Jones also took to Twitter and said, 'So wrong of Archdruid not to honour the Welsh football team at national eisteddfod.'

The Archdruid Geraint Lloyd Owen responded to the accusations of elitism, insularism and linguistic discrimination by telling the BBC, 'If they can't speak Welsh I don't see how we can welcome them in [Gorsedd], because Welsh is the biggest, strongest weapon we have as a nation and without it, we have nothing.' The former Caernarfon Town FC chairman added, 'You'll never please everyone and it would be much better to reward

Will the circle be unbroken? The standing stones at modern Eisteddfods are now made out of plastic.

those quiet people who work for their rural communities or wherever, and taken the burden to make sure things go on, and Welsh is used in the community.'

In among the fury and inflammatory headlines, the National Eisteddfod explained that no member of the Wales Euro 2016 football squad was nominated for a Gorsedd award because the nominations had closed in February – months before the Euro championships began – and it was not possible to reopen nominations once the deadline had passed. It was also pointed out that the Gorsedd of Bards is a separate organisation to the National Eisteddfod and the team were actually invited to come along to the Monmouthshire and District Eisteddfod. The Eisteddfod spokesperson said:

> There have been calls for the Gorsedd of the Bards to honour the Welsh football team at this year's Eisteddfod, following their success at the Euros over the summer.
>
> We are very proud of the success of the team, and they were invited to come along to the Monmouthshire and District Eisteddfod.
>
> The Gorsedd of Bards is a separate organisation to the National Eisteddfod, although there is a close relationship between the two bodies. The Eisteddfod plays no role in the nominating and honouring of individuals, or in any decision made by the Gorsedd Board.

They don't make them like this anymore – the 1913 stone circle that now lies in Swan Meadows.

Like everyone and everything else, the Gorsedd has its rules and only Gorsedd members have the right to nominate or second individuals to be honoured, and of course, it is essential that the person nominated speaks Welsh.

The process for this year's nominations closed at the end of February, and in accordance with Gorsedd rules, it is not possible to re-open nominations once the deadline has passed.

Gorsedd officials have no right to present any honours outside this system, as the Honours Panel is responsible for deciding which applications are eligible.

No member of the Welsh football team were nominated for the Gorsedd and no member of the team was refused the honour.

Over the coming months Gorsedd members will be able to consider and nominate individuals who have made a great contribution to the nation, either over many years of recently. We will see who will be nominated and honoured at the Anglesey National Eisteddfod next year.

Sadly, there were no reported sightings that year of Gareth Bale or Aaron Ramsey kicking the ball about on Castle Meadows while dressed in long, flowing robes.

Foxhunter – A Horse Without Equal

High up on the Blorenge mountain in a secluded, windswept spot, there lies the ashes of Sir Harry Llewellyn. His mortal remains were sprinkled there in 1999, so he could lie in eternal rest close to the grave of his beloved friend: the champion showjumping horse Foxhunter.

The satin-skinned bay gelding was born on 23 April 1941 and was the only horse to have won the King George V Cup three times. Watched by millions on television, he thundered to first place in 1948, 1950 and 1953. He won a record total of seventy-eight international events, won the Prince of Wales Cup five times, jumped thirty-five times for Great Britain and helped to win Britain a gold medal in the 1952 Olympic Games at Helsinki, and a bronze medal in 1948. Foxhunter's last win was at the Dublin Horse Show in 1956. After that he retired and lived a quiet and comfortable life, but was still partial to the occasional hunt.

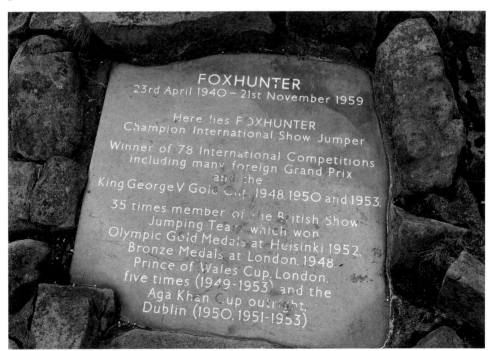

Foxhunter's final resting place.

The partnership between Foxhunter and Sir Harry was legendary. Foxhunter was purchased by Colonel Llewellyn in 1947 and the price he paid was never revealed. Sir Harry used to remark, 'I consider it bad form to discuss Foxhunter in terms of money.' There was one notable incident when Colonel Llewellyn turned down the princely sum of £12,000 from some brash American. Sir Harry simply remarked about his old friend, 'Money could not buy him. He is a member of the family and one might as well ask how much I would want for my son.'

When the inevitable day finally arrived and the old warrior shuffled off this mortal coil to the great showjump in the sky, Sir Harry told the *Chronicle*, 'We had got so used to him here that the place doesn't seem the same without him.' 'He died from an internal hemorrhage. This was caused by a rupture of the artery to one of the kidneys. It was the result of Foxhunter frolicking about in the field, rolling on the ground or a touch of the colic. No-one can be certain what it was,' said the Colonel. When the end came, Sir Harry was, as always, right by his old friend's side.

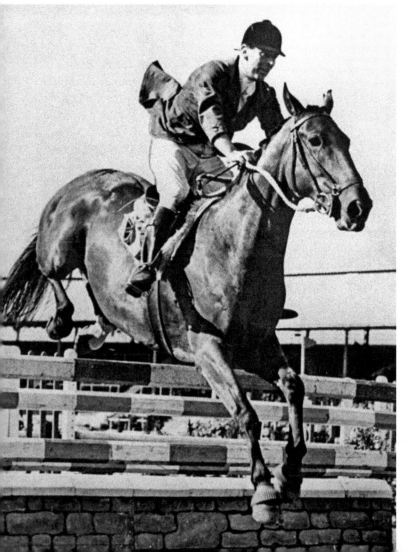

Jumping for glory – Harry and his old friend in action.

G

The Gavenny – A River that Flooded a Town

The Usk is renowned as the river that slices its serpentine way through Abergavenny like liquid mercury, but if you want a true feel for the character of the town then you're better off spending a day wading through the Gavenny than boating upon the Usk.

The River Gavenny has its source at the springs in Blaengavenny Wood, just 1 mile south-west of the village of Llanfihangel Crucorney. It flows southbound for around 4 miles until it loses its identity in the ebb and pull of the Usk, but before it's overwhelmed by those wider waters it plots a trajectory through some hugely historic and atmospheric parts of Abergavenny.

Nowadays the Gavenny is renowned as a gentle and meandering river, but in the year of Our Lord 1931 it was responsible for a natural disaster that came to be known in Abergavenny lore as the 'Great Mill Street Flood'. It happened on a Wednesday night in May. A terrible storm broke across South Wales just after 9.30 p.m. and ravaged the area with a ferocity that didn't ease until midnight: forked lightning, rolling thunder and torrential rain all hatched a plot to batter Abergavenny into meek submission. The downpour was incessant and as it pounded its mocking rhythm on the town's streets, meadows, hills and rivers, the notoriously mellow Gavenny rose like a venomous snake and burst its banks.

A deluge of water swept across Swan Meadows and cascaded into Mill Street like a battering ram. The force of the water smashed through windows and tore down

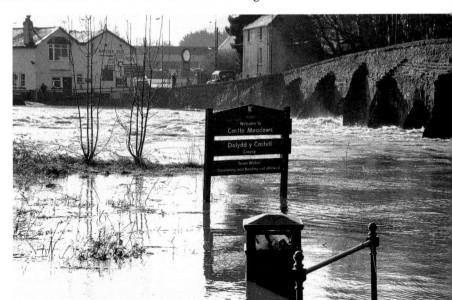

The Usk in all its full-flooded and raging glory.

The Gavenny as it winds his way past Pen-Y-Fal and on to Mill Street.

doors as the lazy old stream was transformed into a raging torrent. 'It was like a sea,' revealed one eyewitness, as the great rush of water caught everyone unawares. The flood was said to have broken across the Monmouth Road like the bursting of a dam. All the residents could do was flee upstairs. In next to no time the lower levels of their homes were completely submerged and the bedrooms were filled with 2 feet of water. Some reportedly punched holes in the ceiling and climbed upon their roofs for safety.

The great flood left a trail of destruction in its wake. The *Chronicle* reported in the aftermath:

> No-one could visit Mill Street without being moved by the pathetic and heart-rending scene which presented itself to the gaze of crowds and people who flocked to the spot. Ruin and desolation were everywhere, but though the tenants of these humble abodes saw their homes wrecked in a night, they, with wonderful fortitude, tried to make the best of matters. It was a sight for tears to see them rescuing from the wreck and cleaning their little household possessions and trying among the hopeless tangle to put their houses in to something like ship-shape order. Everyone marvelled at the spirit of the people in Mill Street and their stoical clam and philosophy in the face of such a calamity.

The road bridge across the Gavenny, Pen-y-Fal's gas mains and No. 1 Asylum Terrace in Monk Street were also washed away in the flood. One of the houses worst hit was No. 3, Court B, Mill Street.

A *Chronicle* reporter visited the home of Mr Poulson and his family and wrote:

In the bedroom I was shown a hole in the ceiling which had been broken in a desperate bid to get on to the comparative safety of the roof. Mr and Mrs Poulson, 16-year-old son Tom, and 11-year-old daughter Doris clambered through followed by their dog, and here they remained until the danger was past. Two cats were imprisoned in the bedroom, but they jumped up on the dressing table and stayed there until it was safe for them to come down.

Mr Poulson told the *Chronicle*:

I have seen many floods but I have never experienced anything like this. We were caught like rats in a trap. When I saw the wall by the garage go crashing down and saw the flood of water rushing at us, I thought, 'O God, it is all over.' We broke a hole through the roof and we stayed there the early hours. It looked as if it was all up, and my little boy said, 'We will all go together'.

The whole of Abergavenny's police force were mobilised and went rushing to Mill Street with an army of volunteers. It's reported that 'Many heroic deeds were preformed which it is impossible to catalogue'. Superintendent Thomas explained, 'It was a herculean task battling with the flood in an endeavor to help the unfortunate people who were surrounded on all sides. It was also a desperately dangerous undertaking and a wonder that all the people were not drowned.' Sadly, in among the narrow escapes, one person did lose their life in the flood: Mrs Vaughan, a widow who lived at No. 45 Mill Street. PC Hughes was attempting to help her through the bedroom window of her house, which was in danger of collapsing, when a strong current swept her from his arms and to her death.

Alongside Mill Street, businesses in Frogmore Street, Queen Street, King Street and other parts of Abergavenny were seriously flooded. The cellars of the Old Herefordshire House were flooded up to the ceiling and beer barrels were floating level with the trapdoor.

The Swan, the White Horse, Britannia Inn and the Butchers Arms were also washed out. The force of the flood also flattened out many of the gravestones at Lantilio Pertholey Churchyard. It's safe to say the great flood of 1931 left a trail of scars in its wake. It took over a year for the local council to obtain funds from the government to commence the rebuilding of roads, pavements and boundary walls.

In July 1932, the owners of the Swan Hotel had become so wary of another flood they made the decision to raise the ground floor to the height of the window sills – hence the steep steps at the entrance. Fortunately, Abergavenny has not been subject to a natural disaster on such a scale since.

As for the Gavenny, it still charts a peaceful and winding course through Abergavenny to merge with the might of the Usk. And, just perhaps, the babbling brook still carries a lazy memory on its cool currents of the night it unleashed its full fury and flooded a town.

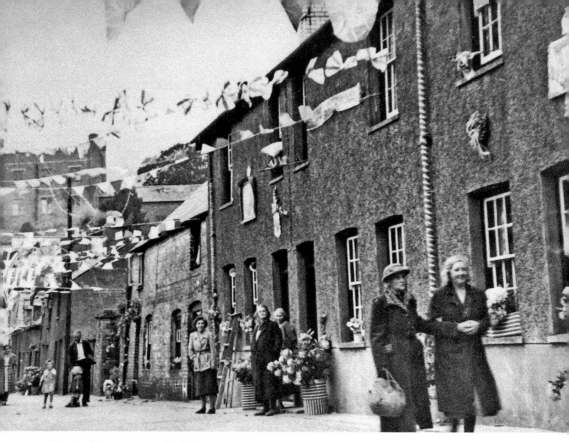

Above: Mill Street as it used to look.

Below: Inhabitants of Mill Street celebrating on VE day.

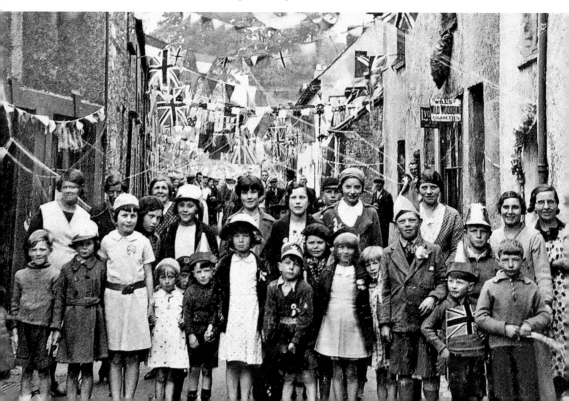

Hidden Tunnels – The Mystery of Abergavenny's Underground Network

A mysterious ancient underground archway that was found by workman carrying out improvement works in Abergavenny's St John's Square prior to the 2016 Eisteddfod baffled local people and those working on the site.

The renovation of the square was part of the £1 million facelift set to revitalise Abergavenny. The significant revamp transformed the Square into a pedestrian-friendly seating area where events can be held. While the diggers were busy digging and the workmen busy whistling, they unearthed a mysterious archway around 5 feet underground, which was probably not a portal into another dimension, but nevertheless looked pretty impressive and strikingly historic.

Work was immediately halted in the wake of the surprise find and Monmouthshire County Council were contacted to determine if the arch was of archaeological importance. The site manager informed Monmouthshire County Council who instructed him to back fill the hole. The site's clerk of works believed the archway could be an entranceway to a cellar or possibly a culvert, but the rest of Abergavenny

A portal to another dimension? Or maybe just an old wine cellar?

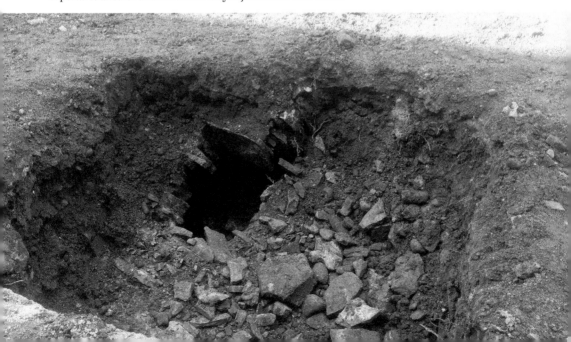

St John's as it used to look way back when.

were not so sure. Rumours have long circulated in the town that an underground tunnel network exists in Abergavenny that begins at the castle and leads to St Mary's Priory Church. Had the hard-hatted workers accidentally discovered one such archway that would open a door on a medieval maze of Machiavellian intrigue? Or perhaps the mysterious archway merely led to a long abandoned cellar, belonging to one of the many Elizabethan houses that were systematically destroyed during the town's slum clearances in the 1950/60s to make way for the sharp-edged utilitarianism and banal box designs of modernity that transformed Tudor Street and St John's Square beyond all recognition?

The more adventurous suggested it led to an underground network of tunnels once used by none other than the legendary Prince of Wales Owain Glyndwr, who guided his troops through the dark and winding maze to breach Abergavenny's walls and plunder the poor old unsuspecting mother duck senseless in 1404. There were even fantastical suggestions that the underground arch formed part of an entrance to a dungeon once used by the now defunct Chevron nightclub to dump their more rowdy clientele until they had a chance to sober up. Some even claimed the archway was a secret portal to the labyrinth of a supernatural and terrible beast-like creature that had lain dormant beneath the Gateway to Wales for centuries, but which was now awoken by the inferno of modern machinery and men in high-vis jackets. Many feared that unwisely prodding this foul scourge of centuries was like hitting a grumpy bear with a big stick and might just cause it to rise from its slothful slumber and go berserk in time for the National Eisteddfod.

As theories go, most of the above are pushing the envelope somewhat, but the existence of an ancient tunnel network beneath the streets of old mother Abergavenny stirred something timeless in our modern souls: the fascination of that which lies beneath.

Our fascination with underground spaces and passageways is as old as the hills. They loom large in our psyche as dark and remote portals to an otherworld where magic and wonder hold sway. Underground spaces are one of the few areas left on this spinning rock we call home that remain untouched, untainted and unshackled by civilisation.

The tunnels are now considered something of an urban myth, but rewind a few decades and many locals appear to have taken their existence for granted and thought it was no big deal. For example, many castles scattered across the UK did contain underground tunnels that led to the outskirts of the town for the nobles to disappear into in case of a prolonged siege. Both Loundon Castle in Scotland and Nottingham Castle were found to have escape tunnels, and in the 1950s a tunnel was found in the basement of the Angel Hotel in Cardiff, which was said to have connected directly to the castle. So why not Abergavenny?

Although there are no written records or plans to confirm their whereabouts, there is a strong oral tradition in the town that the aforesaid tunnels do exist. In his book *Historic Notes on Abergavenny*, the author John G. Williams writes,

> One such tunnel is supposed to pass under Nevill Street and then down Frogmore Street, and some years ago signs of this were discovered at No. 61 Frogmore Street, when it was in the occupation of Mr. Owen, the Chemist. Another tunnel seems to have been in the Cross Street area as some time before 1939 one of my friends remembers a motor car being driven under the archway at the King's Head Inn when the ground underneath it, near the old stables, fell in and revealed an underground tunnel that was partly filed in. Farther down the street the remains of a tunnel was discovered when workmen were excavating to build the underground strongroom for the present site of Lloyds Bank Ltd. These might be the remains of a tunnel from the Castle to the Priory Church, and I have heard that this tunnel is supposed to travel as far as the very old farmhouse called Wernddu in Llantilio Pertholey and adjoining the Abergavenny to Ross Road.

In 2017, a photographer uncovered a stunning 700-year-old complex in Shropshire. The entrance to this underground world looked barely bigger than a rabbit hole and was apparently used by the Knights Templar. We're getting into the topsy-turvy world

Murk and mist – what secrets lie beneath the grounds of Abergavenny Castle?

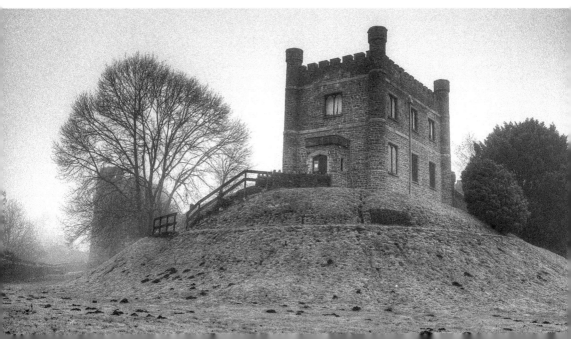

of conspiracy theories here, but apparently the Knights Templar were said to have been fans of tunnels in a big way.

There's not any documented evidence of Knights Templar activity in Abergavenny but there is an effigy of Sir John De Hastings in St Mary's Church. The effigy of Hastings is carved cross-legged, which was once thought to imply that the deceased had served in the crusades, had taken crusading vows or, more specifically, had been a Knight Templar. Hastings acquired Abergavenny Castle and significantly contributed to the fourteenth-century rebuilding of the priory. What better opportunity to build a tunnel network between the two historic sites?

Monmouthshire County Council did eventually get to the bottom of the mysterious archway in St John's Square. A spokesperson for the authority said,

> Whilst undertaking excavation works to plant trees in St John's Square, our contractor uncovered an underground structure which appeared to be a cellar. To make the area safe, the excavated void was filled with soft excavated material. Examination of the historic maps indicated that there was a row of houses and, in particular, a public house at or near this location. These properties were demolished circa 1960. It seems most likely that the structure is the cellar of the public house which formerly occupied the site.

So there we have it. The archway that got everyone gossiping was probably a pub cellar, but the wider mystery of Abergavenny's network of tunnels rumbles on. All anyone can hope to do is follow the white rabbit and get digging!

What mysteries are buried in Aber's alleyways and avenues?

I

Father Ignaitus – A Monk on a Mission

In 1870, a Church of England clergyman going by the name of Revd Joseph Leycester Lyne purchased a 34-acre farm on the outskirts of Abergavenny called Ty Gwyn. In March of that year Joseph and his followers began building a monastery, whose purpose was to revive the Benedictine monastic way of life. Before the monastery was finished, Joseph, caught in the fierce grip of the Catholic revival, would change his name to Father Ignaitus and a local legend was born.

Father Ignaitus would earn renown as an Old Testament preacher whose oratory skills were second to none. His firebrand style of speaking and the zeal with which he spread the word would see him earn renown as a household name. He toured both the United States and Canada to deliver his booming sermons.

Father Ignaitius was a no-nonsense type of guy. A sort of Al Capone in a monk's habit. He is often regarded as being more at home with preaching the gospel to the

Father Ignaitus and Our Lady of the Sorrows.

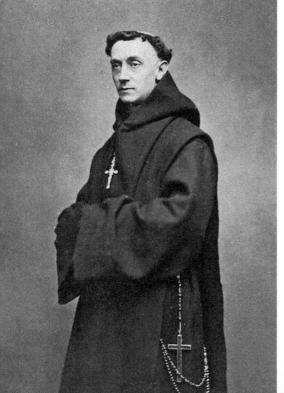
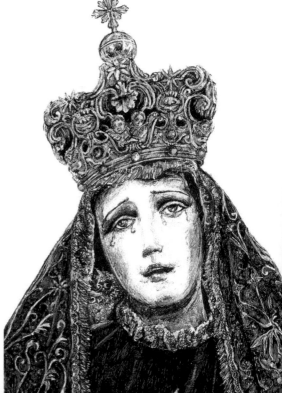

drunks and ne'er-do-wells of Abergavenny than he was towing the line for the church authorities who often viewed him with disapproval.

Writing in Victorian Studies, David Hilliard suggested that Father Ignaitus was 'part of an Anglo-Catholic underworld whose members delighted in religious ceremonial and the picturesque neo-Gothic externals of monastic life. These groups did not enforce strict criteria for entry and it is likely that they were especially attractive to homosexually inclined young men who felt themselves drawn to the male environment of a monastic community and the dramatic side of religion.'

During his thirty-eight-year tenure at Llanthony, over 300 men of all ages came to stay and study with Ignaitus, who was said to have possessed a deep spirituality and whose face shone with a heavenly light whenever he prayed. He was also said by his contemporary, Anglican diarist Francis Kilvert, to have often been surrounded by ghosts 'who will never answer though he often speaks to them'.

Visions of the Virgin Mary gliding across the grounds of the monastery were said to have been seen by various witnesses in August and September 1880, and the flickering appearances of Our Lady of Sorrows on the site has since been commemorated with a statue that stands on the forecourt outside the monastery.

Father Ignaitus died in Surrey on October 1908 at the age of seventy-one. His mortal remains were carried back to the home he loved in a hearse drawn by a team of white horses. He was laid to rest beneath the floor of the abbey church he had given so much of his life to.

The Lady of Llanthony statue, which stands in front of the monastery.

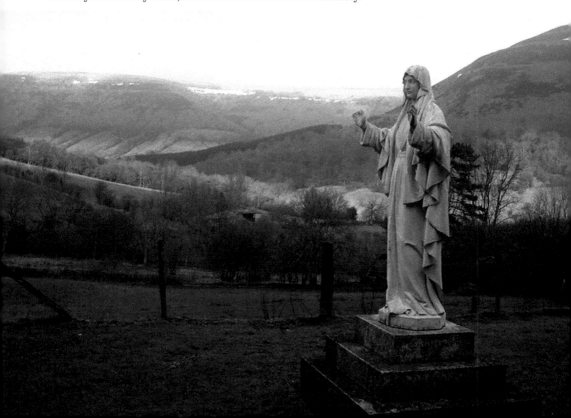

Joseph Garcia – The Spanish Butcher

It remains one of the bloodiest crimes in the history of Monmouthshire and its gory details and murderous circumstances still chill the blood and freeze the marrow of those who stumble across the story of the young Spanish seaman who slaughtered an entire family in Llangibby over a century ago.

Although it happened on the outskirts of Abergavenny, the case of twenty-one-year-old Joseph Garcia and his crimes of callous carnage sent shockwaves throughout the town in the year 1878. After serving a nine-month term in Usk Gaol for burglary, Joseph Garcia was released to roam the world at large on 16 July 1878. The stereotypical stranger in a strange land, Garcia could only speak a few words of English, but his subsequent actions spoke volumes in any language.

The River Usk charts a course from Abergavenny to the town, which bears its name and hosts a historic prison.

On the same day he was given his liberty from prison, Garcia hadn't travelled very far when he made a port of call at Llangibby's Castle Cottage on the road to Usk. With disturbing parallels to our own age, the young Spaniard wasted little time in proving that he had not learnt any lessons while in prison and he committed much more than just another burglary. In his foul wake he left inside the blood-splattered walls of that cursed cottage, the badly mutilated bodies of farmworker William Watkins (forty), his wife Elizabeth (forty-four) and their three young children.

The scenes inside the cottage were like hell on earth and indicated that husband and wife had put up a long and hard fight for survival before succumbing to stab wounds, while their children Charlotte (eight), Frederick (five) and Alice (four), were hacked to death as they slept. To cap his bloody handiwork, Garcia set fire to the cottage in three different places before taking his leave.

A young lad named Frank James who worked for Mr William Watkins found the murdered man, in his own words 'asleep in the garden', and rushed away to tell his mother.

One of the first witnesses upon the scene, Mr. E. George of the White Hart Inn, recalled, quite fittingly considering the demonic and diabolical deeds that had taken place there, the overwhelming smell of sulphur. In the police records of his witness statement, Mr George recalled:

It was about seven o' clock in the morning when the little boy [Frank James] came here [White Hart Inn] and said 'Mr Watkins has been killed.' I went up to the place at once to see what was the matter. When I got there I found Mrs Watkins lying dead inside the gate and her husband was lying dead about four yards from her.

Smoke was issuing from the top of the house. We succeeded in opening the door leading upstairs to the bedroom, but the stench of what smelt like burning sulphur was so powerful that we could not go in, so we went outside and broke some slates off the roof. This let the stench out and we then entered the bedroom.

Greeted with the grimmest of scenes, George describes how the children were all lying dead on their beds with their throats cut and how all three of them had been badly burnt after being butchered. Quite poignantly, it was also discovered that the clock face had also been taken out of the family's timepiece and the pendulum thrown upon the ground, as if to give the world a chilling reminder that time had stopped completely for the Watkins's household on that day.

A *Chronicle* reporter later allowed to visit the scene by police wrote:

A demon-like vengeance had been lavished on every article of furniture. The woman's throat was not only cut, as were also the childrens, but she was stabbed in several places, and one of her hands was maimed, apparently with a sharp instrument. The man appeared to have been dealt with in much the same way. Another peculiarity in connection with this dreadful affair is the circumstance that the poor woman's body was covered with wallflowers plucked from the garden, and strewn over the corpse as though in mockery.

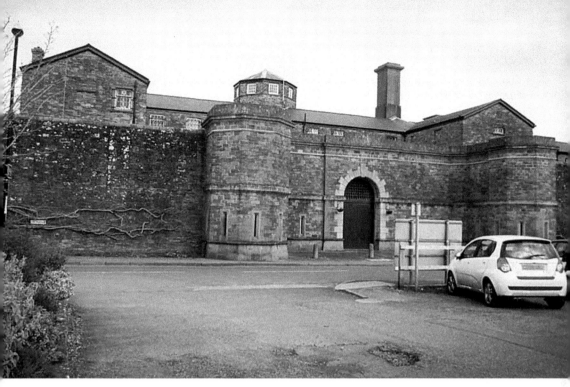

The prison from where Garcia was released to commit his awful atrocities.

Joseph Garcia, who was seen loitering a short distance from the Watkins's house – once in the morning, once in the afternoon and once in the evening – by three independent witnesses before the murder was committed, was arrested at Newport railway station the following morning between 12 noon and 1 p.m. after police had issued a description of the suspect. A policeman had observed a man matching Garcia's description go to the fountain for a drink. He accosted him and, finding his words were not understood, asked Garcia whether he was a Frenchman, a Spaniard or an Italian. Getting nothing out of him, he informed a certain Sergeant McGrath, who recognised Garcia as a desperado who had recently been imprisoned at Usk Prison for a burglary committed at St Brides.

Garcia was arrested wearing a black cloth coat, round bowler hat and dark trousers. He also had on a pair of boots the same size and make of the murdered man. His clothes were very wet, and there was blood upon his wrist. His left cheek was slightly scarred as though with a sharp instrument.

With regard to Garcia's personal appearance, it was said to be not at all alarming. He was described as being of a slight build, short, having a long sharp nose, thin features, and small eyes, surmounted by a thick shock of black hair. His manner was recorded as being composed, and he spoke in a decided tone in reply to the questions put to him, without displaying the faintest symptom of emotion of any kind.

He denied all charges and when asked how he accounted for the considerable property in his possession which belonged to the murdered people, he said he found it. At his committal hearing at Caerleon Magistrates the crowd in and outside the court was enormous and the *Chronicle* reported,

The noise outside the court was powerful enough at times to prevent the witness from being heard, and from the character of the exclamations which permeated to the interior of the court the crowd appeared ready to lynch Garcia. Although the babble of contending voices was at times perfectly deafening, the prisoner preserved a calm demeanour throughout the trial. The only movement visible on his features was the shooting to and fro of his eyes - very dark and very brilliant, which at times betrayed a latent interest in what was going on.

At the Monmouthshire Assizes held in October it was argued that nobody would probably ever know the motive of the man who committed these murders, but it might just be that the prisoner was refused a night's lodging or some food by the Watkins household, and then committed the crime.

In his summing up, the judge urged the jury to remember that Garcia was not seen all the day after the murder, that he was found with the stolen goods, and that he had blood upon him. The jury found Garcia guilty, and he was sentenced to death. The condemned man betrayed no reaction on being informed of the sentence.

Garcia apparently did not sleep well during his last night on earth, and when he rose between 6 and 7 a.m. on Monday 18 November to await the noose at Usk, he failed to eat his breakfast. When the notorious executioner William Marwood, who

The *Abergavenny Chronicle* team at the time of Garcia's bloody reign of terror.

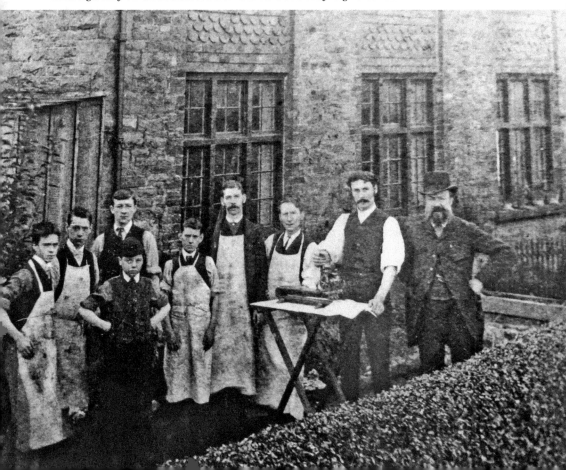

developed the more merciful 'long drop' technique of hanging, bound Garcia's arms to his sides, the prisoner submitted with the greatest meekness and appeared as if all his physical strength had left him. Uttering pious exclamations to the end, Garcia was heard to say on three occasions, 'I am innocent, I never did it.'

An *Abergavenny Chronicle* reporter on the scene wrote somewhat eloquently of the execution:

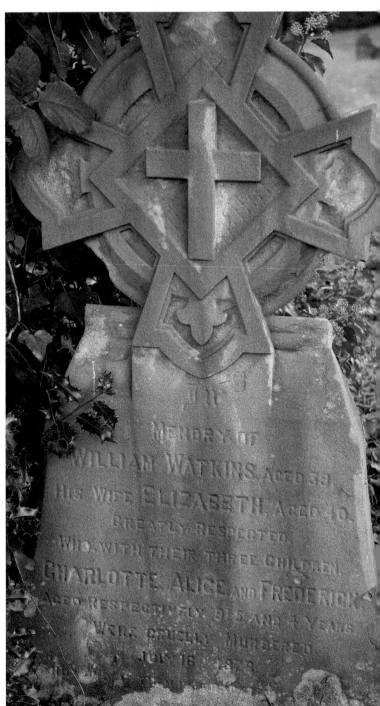

The final resting place of the Garcia family.

The justice of the rope.

The poor wretch Garcia presented a ghastly figure as the procession made its way to the repulsive looking scaffold. From the cell to the scaffold was only a few paces, but, few though they were, they were too many for the wretched culprit. His strength entirely deserted him. The shadow of death had already fallen upon him.

He was dressed in his blue sailor's trousers and his blue jersey. His face and neck were colourless. As soon as he saw the scaffold he gave one glance at it, and shut his eyes. From this time he was completely overcome. His head swung helplessly from side to side as if his life had already fled. His strength had utterly gone and he was partly supported, partly dragged, up the steps by the warders who were on each side of him.

Hovering as near his person as the presence of the warders would permit, was Father Echevarria, the Spanish priest, whispering short prayers and pious ejaculations in the ear of the doomed man.

With Garcia finally stood upon the drop, the last moment had now come. Father Echevarria stepped forward and pressed his little crucifix to the lips of Garcia, who smiled faintly and said in the Spanish tongue, 'My mother! Let the Spanish counsul write to my mother.

Quick as thought a white linen covering was thrown over Garcia's face. Equally quick was the rope placed around his neck, and admist the prayers and invocations of priests, Garcia was hurried into the presence of the Great and Righteous Judge who cannot err.

K

The King of Abergavenny – Elvis Davies

Bob Dylan once said about the 'King of Rock 'n Roll', 'Hearing Elvis for the first time was like busting out of jail.' Not one for understatements himself, John Lennon also famously declared, 'Before Elvis there was nothing.'

Abergavenny's Keith Davies would agree with such sentiments. Keith's a massive fan of the simple country lad who turned Western culture on its head with a beaten-up guitar and a crooked smile. He's not just a fan, he's an impersonator, and one so good at what he does that he's raised over £300,000 for charity. Such is Keith's fame he is now simply known as the Abergavenny Elvis.

The King, recycled and reborn.

'If it wasn't for rugby I probably would have never ended up as an Elvis tribute act,' explained Keith. 'It was through going on tour with the boys and following Wales to places such as Scotland and France that the whole thing kicked-off. I'd get up to do a turn on the karaoke after the match, and the Elvis songs I sung would always go down a storm.'

Although performing these songs to pubs full of drunken rugby fans, Keith still gave it his all, and was 100 per cent dedicated to doing the King's legacy justice. 'Since the age of ten I have been a true blue Elvis fan,' Keith explained when reminiscing about the very first time he laid eyes on the King. 'It was the televised concert he did from Hawaii which initially made me a life-long believer in the "church of Presley". It was like a moment of revelation. I remember sitting wide awake in front of the TV thinking, "Who the hell is this guy?" From that moment on Elvis was my number one hero, and what is the first thing you do when you have a hero? You try to emulate them.'

Keith's reputation as the Abergavenny Elvis began in earnest when a friend who knew of his talent on the karaoke asked him if he would be interested in doing a charity concert as Elvis at Llanvapley village hall. Jumping in at the deep end, and backed by a group of friends calling themselves 'The Memphis Mafia,' Keith committed himself to performing two one-hour-long sets in front of eighty people.

'In the ghetto' – Keith takes to the streets with his hound dog on a bicycle made for two.

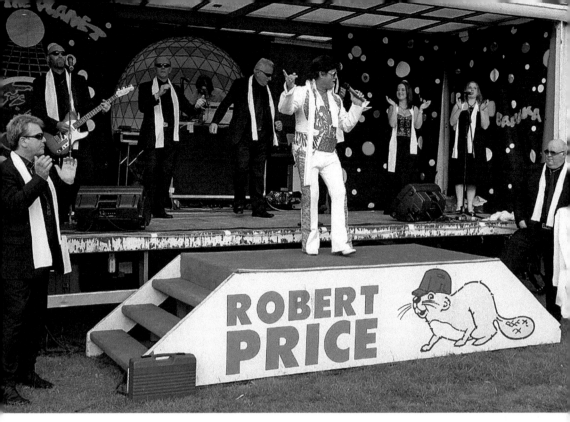

Elvis and his Mafia rocking the crowds in Bailey Park.

After the success at Llanvapley, word got around and the momentum built as Keith started playing and drawing record crowds to other village halls, where he made his entrance in grandiose fashion on Harley Davidsons, limousines and, on one memorable occasion, a helicopter. Speaking about performing Keith explained, 'The only workable way for me to do what I do, is to actually become the persona of Elvis completely for those two hours I am on stage. As soon as the show's finished I'm Keith again.'

Since Keith became the Abergavenny Elvis he has visited Graceland, met Priscilla and Lisa-Marie Presley, and various members of the original Memphis Mafia. Looking back on the highlights of his time in the spotlight Keith said,

> I never dreamt that when we agreed to do that first show it would eventually turn out like this. For a long time now we've been riding a crest of the wave. Yet we know that one day the bubble will burst and it will all end as quickly as it began.
>
> We're not worried though, because we never take ourselves too seriously in that respect. At the end of the day we're just a bunch of hard-working fellas that are having fun doing what we're doing for as long as it lasts.
>
> The biggest buzz for all of us however, has got to be that every show raises more and more money for charity.

When asked about what Elvis continues to mean to him Keith said,

> The whole act started through a love of the music and showmanship of Elvis Presley. So many people have always been quick to knock Elvis but no-one knows what it was

And he's off! Elvis leaves the scene of the crime in style.

like to walk a mile in his shoes, and at the end of the day for all his talents he was a human-being who made mistakes like we all do.

As far as I'm concerned Elvis has helped to show me how much fun life can be, and that it's not all about taking, but about giving as much as you can.

In a world full of Elvis impersonators, some do it for the dollar, some do it for the ego and some do it to have a good time in the name of worthwhile causes. Keith Davies falls into the latter category and, as such, is truly carrying out the King's sacred duty. Uh-huh!

L

Linda Vista – A Beautiful View

Nestled between Tudor Street and Castle Meadows, Linda Vista Gardens is a haven of tranquillity and landscaped gardening for the wandering soul to lose themselves in. Translated from the Spanish tongue as 'beautiful view', it's not hard to see why. Amid the brooding backdrop of the mighty Blorenge, there's a wealth of orchids, shrubs, and unusual specimen trees for those with a passing interest in botany to meander gaily through. Linda Vista Gardens is not just a sanctuary of solitude that the manic mind of the modern era can contemplate nature's unbounded glory in, it's also a rare retreat of curious history.

Rewind the clock to the nineteenth century and Abergavenny was a somewhat unsavoury place in which to dwell. Appalling sanitary conditions entailed that clean water was a luxury and the air was often foul. A report from 1847 described parts of Tudor Street as 'indescribably filthy and almost unapproachable from the stench.' It was into this cesspit and cauldron of poverty the Jenkins brothers were born.

William, John and Henry were not happy with the lot fate had drawn for them and so left their humble abode in Chicken Street (now Flannel Street) to find their fortune in Chile. Although the South American country may seem like a strange shore for a trio of young Welshman to pursue their dreams, Chile at the time had strong links with the UK. In 1811 the country declared independence from Spain and their Navy was headed by Britain's Admiral Cochrane. The UK had strong business interests in

A thing of beauty is a joy forever. The house that Henry built.

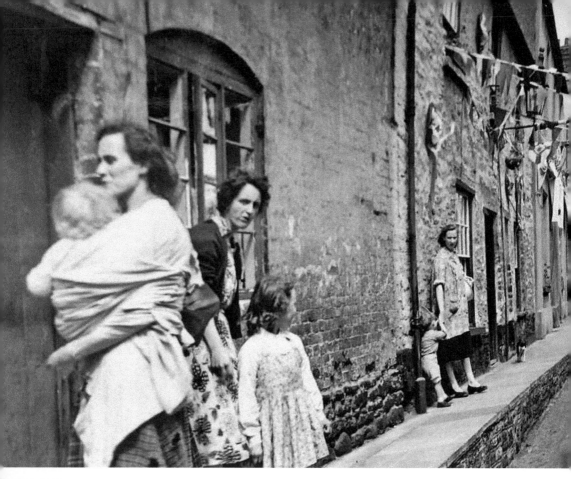

Above and left: Visions of Tudor Street as it once was.

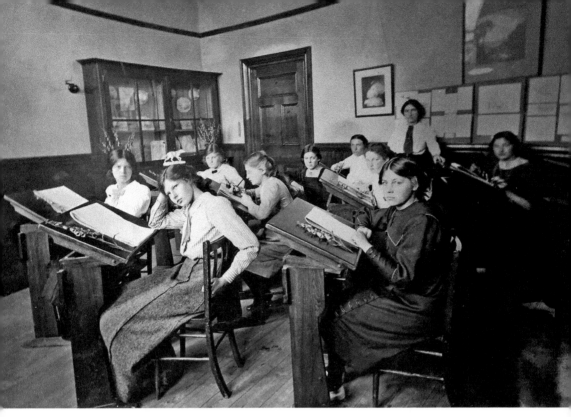

The happiest days of their lives – pupils enjoy a day's learning at the Harold Road Girls' School.

Chile because of its wealth of mineral resources such as copper and sodium nitrate, which was used to make explosives and fertilizer.

The Jenkins brothers never became copper barons or nitrate kings but they turned a healthy buck through building warehouses for the exporters and houses for the workers. Having made his fortune, Henry, his wife Mary and their six children returned to dear old Abergavenny, where the lad from Chicken Street upped his game, splashed the cash and moved into a plush residence in Brecon Road where he employed two live-in servants. While lording it in his new abode, old Henry had a much bigger manor built overlooking the River Usk and shielded from the none too salubrious quarter of Tudor Street by a wall of fine foliage.

Completed in 1875, Henry's new house was named Linda Vista, but he never really got to appreciate that 'beautiful view' all that much because two years later he died. His legacy certainly lives on, though.

The Whitehead family, who owned the Ebbw Vale steelworks, purchased the house and ground in 1925 before selling the garden to the Abergavenny Corporation in 1957 for the public's pleasure.

Henry was not alone in leaving a lasting footprint on the face of Abergavenny. His brother William, who died in 1893 aged seventy-four, retired to The Willows in Pen-y-Pound and owned much of the land, which is now known as Avenue Road. He also donated the plot for a girls' school to be built on Harold Road, which after numerous changes through the years is now named Cantref Primary.

It's certainly an eye-opener to find out just how much of Abergavenny was built with Chilean coin.

3rd Mons – The Horror and the Sacrifice

A special service was hosted at St Mary's Priory Church in 2017 to commemorate 3rd Mons Day and remember the heavy casualties the Abergavenny-based battalion suffered at the Battle of Frezenberg Ridge.

The Monmouthshire Regiment, formed in 1908, consisted of three battalions drawn from different areas of the county. Abergavenny was the headquarters of the 3rd Battalion (3rd Mons), which included two companies from Abertillery, one each from Blaina, Sirhowy, Tredegar, Ebbw Vale and Cwm and one company from Abergavenny.

Also known as the third engagement of the Second Battle of Ypres, the Battle of Frezenberg Ridge saw a total of 526 men from the Monmouthshire Regiment lose their lives in the Belgium killing fields of the First World War. A further 799 were wounded. The Battle of Ypres has becomes notorious, not only for the terrible loss of life, but also because it was the first time that the German army used poison gas on the Western Front. During a furious and prolonged German assault, the men of the Third Battalion suffered the heaviest fatalities.

On 8 May 1915, the Monmouthshire Regiment were tasked with defending the strategic ridge and preventing the Germans from occupying the Belgium city of Ypres

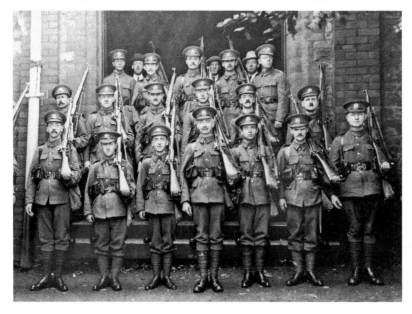

Soldiers from the 3rd Mons pictured outside their base in Abergavenny, the Drill Hall.

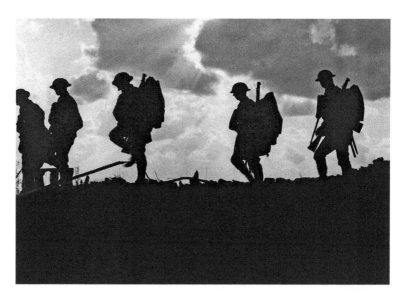

Troops making
their way towards
Frezenberg Ridge.

and seizing the vital channel ports. Outnumbered, out gunned and against the odds, the Monmouthshire battalions held fast and stood their ground. But at great cost.

By the end of the first day, 211 men had fallen. Before the engagement ended on 13 May hundreds more would join their rank. As the carnage unfolded in a terrible mass of gunfire and shelling, the Monmouthshires endured day after day of relentless German attack as they struggled to hold Frezenberg Ridge.

Prior to Frezenberg, the first engagement of Ypres was the Battle of Gravenstafel Ridge (22–23 April 1915). It was here that chemical warfare reared its ugly head for the first time and proceeded to play a monstrous part in defining the fearful symmetry of the First World War. German troops opened 5,700 gas cylinders containing 168 tons of chlorine gas and released the deadly poison to the wind. The indiscriminate poison turned on many of the German troops who were killed and injured when carrying out the attack. However, it was the 6,000-plus French troops in the direct path of the gas cloud who were hit the worst. The gas caused men to froth at the mouth as they died a violent and agonizing death. Those who managed to survive were temporarily blinded and, as they stumbled from their trenches into no-man's land, they were mown down by enemy fire.

The use of chlorine gas had allowed the Germans to advance and gain a tactical advantage. As the battle went on the Allies fashioned their own makeshift defence against the gas. They found by urinating on a piece of cloth and holding it to their face they could counter the deadly effects.

Prior to the Battle of Frezenberg Ridge, the 3rd Mons were subject to a relentless German bombardment on the evening of 4 May. Casualties were high and the front-line troops soon became exhausted.

Captain O. W. D. Steel, who was a doctor in civilian life, led a company of troops to reinforce the front line. Many were cut to ribbons by the fierce German machine gunfire. As he was leading the advance, Captain Steel also attended to the high number of casualties. He was later awarded the Military Cross for his actions. Private A. M. Mitchell wrote home to commend his captain's courage:

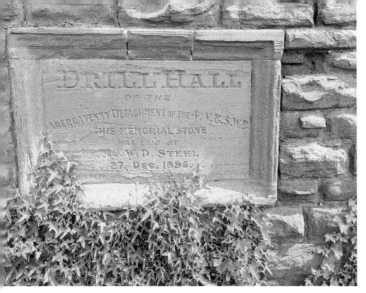

A plaque on the old Drill Hall building, which is now Baker Street cinema.

Words utterly fail me to say what a hero Capt. O. W. D. Steel was during that fearful struggle. From every person I meet they tell me the same tale. Under very heavy shell and maxim fire he went out and fetched in wounded, bandaging them and if he doesn't deserve the V.C. no man on earth ought to get it ... I would like you to let everyone in Abergavenny know what a brave officer he is.

After retiring to battalion headquarters, weary, worn, and with hundreds of their brothers in arms dead, the 3rd Mons were ordered to carry out a counter-attack on Frezenberg. While holding Frezenberg Ridge, the troops experienced a hell and horror without equal. Private Badham, of Abergavenny, wrote to a friend from hospital:

The 8th was the day I shall never forget. They started bombarding the same time in the morning, and about half an hour afterwards we could hear a long blast of a whistle, and the attack started. We were only a handful of men, and they came on in thousands, but we kept them at bay; but I knew we would have to give way before long. The fellows on our left and right were retiring and we had orders to do the same, but we did not go until we put some more shots into them.

It was in the retirement that we lost a lot of men. They were bayoneting our wounded that we had to leave behind. Well, we got back to our second line of trenches, and reinforcements came up. After that I don't know what happened. I went to the hospital with shrapnel in my back and a big bruise on my shoulders and the gas in my eyes.

Due to the fierce fighting at Frezenberg and subsequent engagements, by 28 May the mauling of the three Monmouthshire battalions was so complete they were amalgamated. It wasn't until 11 August that they resumed their own separate identities.

A year previous to the Battle of Frezenberg Ridge, the brave men who made up the 3rd Mons had little idea of the apocalyptic carnage that would take the lives of so many and leave the survivors changed men.

It was a glorious August day when the entire battalion of the 3rd Mons gathered outside Abergavenny Market Hall on 5 August 1914. Dawn was breaking and the air was full of promise. Jovial and full of high spirits the troops marched to Bailey Park for morning tea. The battalion colours were handed over to the custody of the town

mayor. The soldiers then proudly marched out of the town to the railway station as crowds cheered and flags were waved.

Sitting aboard a train bound for Pembroke Dock, many of the Monmouthshire men would have gazed out of the windows at the surrounding mountains. As the Blorenge, the Sugar Loaf, the Skirrid and the Deri faded from view, some may have even felt the first pangs of homesickness and uncertainty about the road ahead. Most would have felt excited about what would have been through the optimistic eyes of a young man as the adventure of a lifetime. That optimism was to be cruelly short-lived.

Of the 1,020 soldiers of the 3rd Battalion of the Monmouthshire Regiment who had arrived in France in February 1915, only a scattered few remained alive to see the dawn break on the morning of 9 May.

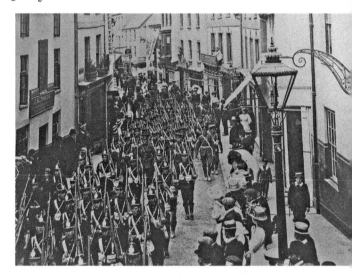

On the march.

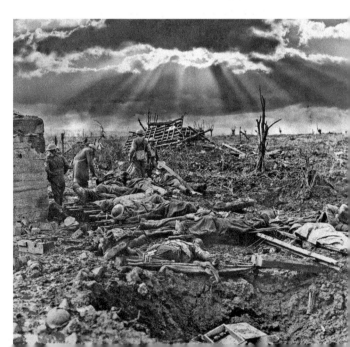

The terrible aftermath.

Nevill Hall – From Country Manor to Hospital

A lot of people can lay claim to being born in Abergavenny. And that's because a lot of people were, courtesy of Nevill Hall Hospital, which has a catchment area that covers Monmouthshire, the South Wales valleys and Powys.

Purpose-built and officially opening its doors in 1970, Nevill Hall was built to replace the Victorian hospital, which still exits on the grounds to the rear of the modern complex. The site has a medical association going back to the eighteenth century when Dr Samuel Steel owned a small tenement building located there called the Brooks .

In 1860, one of the owners of Blaenavon Iron Works – James Charles Hill – purchased the site, demolished the house and replaced it with a far grander one. The Tudor-Gothic character of which was enhanced by its elaborate and landscaped gardens. Thirty years later the Marquess of Abergavenny, William Nevill, or to give him his

The old hall in all its Gothic splendour.

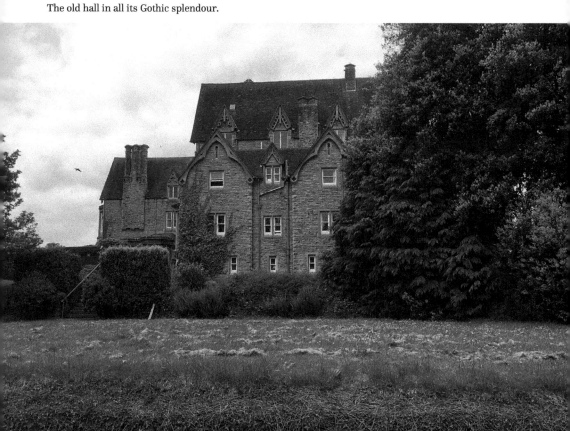

A neglected pond to the rear of the great house.

more modest title, Lord Abergavenny, appeared on the scene like an over-privileged knight on a white horse and decided to buy the house and set up home there.

Since the town's castle had fallen into rack and ruin, the Nevill family did not have an official residence in the town, but this all changed when William returned to the manor and renamed his new dwelling Nevill Court, later to be known as Nevill Hall.

In 1915, the marquess met his maker and the *Abergavenny Chronicle* gushed, 'It is no exaggeration to say that Abergavenny has lost the best friend it ever had, for although his lordship spent most of his time at his beautiful Sussex seat, he retained to the last a real affection for the town among the hills, and helped forward its interest and prosperity in every possible way.'

It's worth noting that in 1899 the marquess was offered the mayorship of Abergavenny but he refused and became the town's first honorary freeman instead – the ceremony took place at Nevill Hall on 5 November 1900.

The marquess is also remembered for presenting the mayoral chain of office to the town – at his own expense and from a design he selected himself. It has been worn with immense pride by the town's citizens for over a century.

In the wake of his death, Lord Abergavenny's entire estates, with the exception of the castle grounds, which the Nevill family still let to the town for recreational use, were sold.

In 1919, the Blaina and District Hospital purchased Nevill Hall for use as a convalescent annexe. During the Second World War it was occupied by the military

The Nevill Hall of today looks very different from the Nevill Hall of yesteryear.

and, not long after the formation of the National Health Service, it opened as a hospital in January 1953.

Today the old hospital is used as an administration office but it still retains all of its old splendour and spectacular windows, which command superb views of the surrounding countryside.

The original Nevill Hall stands as a stark reminder of the past and provides the idle eye with an interesting contrast between the hospitals of yesteryear with the hospitals that sprung up in the 1960s and '70s when governments realised they were something worth investing in.

O

Ostringen – A Bond Born on the Terraces

Football is often referred to as the 'beautiful game', not purely because of the silky skills of its prize participants but also because it's renowned for bringing people together from all walks of life. Nearly half a century ago a gang of hardcore fans of the 'pigskin sport' became largely responsible for Abergavenny's blossoming and burgeoning relationship with its German twin – Ostringen. Here's how.

Way back in the swinging '60s, the fair county of Monmouthsire was twinned with the German city of Bruchsal as part of the European Friendship Plan. Bruchsal is also renowned for being Europe's largest asparagus producer. The town mayors of Britain and Burgermeisters of Germany were also told to 'twin-up' in a hurry, which led to the 1968 twinning of Abergavenny and Ostringen – one of the towns located within the Bruchsal area.

Flying the flag for the twin town.

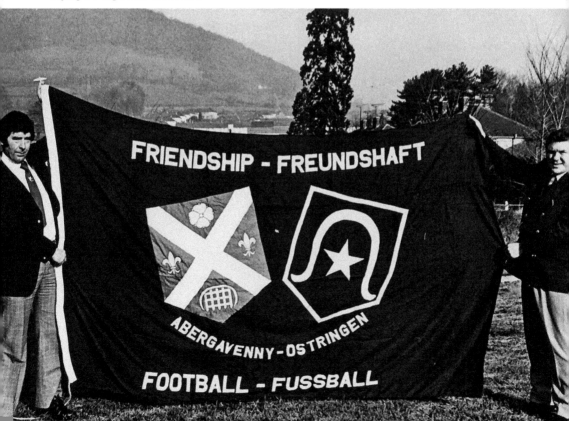

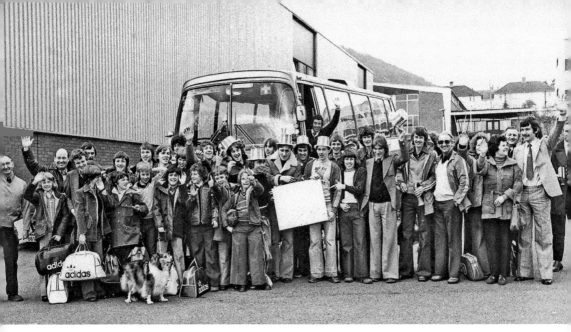

The Abergavenny contingent waiting to depart for Deutschland.

Over the next two years a series of councillor visits and number of school interchanges involving small numbers took place, but the trips didn't exactly set the two towns on fire and forge a cast-iron friendship. Things weren't going to plan or working out how the two towns hoped. The situation had become dire, leading Ostringen's Burgermeister Hermann Kimmling to do what most people do when things go belly up, he wrote to the local newspaper. His letter, which appeared on the front page of a 1970 edition of the *Abergavenny Chronicle*, expressed deep distress with the lack of progress in the twinning relationship. He ended the letter by pleading with the paper's readers to send their ideas directly to him about how to energize the exchanges and make the twinning project a sure-fire success.

That particular postbag caught the wandering eye of former Abergavenny Thursdays player and football coach Terry Hodgins, who had hung up his boots and was scouting around for a new challenge to get his teeth stuck into. Putting his thinking cap on, Terry pondered, 'What do both Germany and Britain have in common?' The answer hit him like a thunderbolt: 'Their mutual love of football!'

Terry, who is now a sharp and youthful-looking eighty-seven-year-old, explained, 'It occurred to me that the only way to gee things up was with a sport that was dearly loved in both countries. So I dug out my decrepit typewriter and knocked off a short note and posted it to the Burgermeister saying that I believed that a programme of youth soccer would be the best way forward.'

Within a week Terry received a letter addressed to Herr Hodgins from the Ostringen Burgermeister. Only trouble was, it was written in German. Terry explained, 'I had the letter translated by a German lady living in Monmouth Road who charged me the sum of one pound for her troubles.' It was well worth it. The letter revealed that Herr Kimmling was wildly enthusiastic about Terry's idea and that tiny spark ignited a mighty bonfire.

Terry teamed up with Les Townsend of Abergavenny Park Rangers FC (U16) and Alf Barker of Llwynu Utd (U14), who supplied the fundraising and admin know-how, to partner his own coaching experience. The trio were joined by first-class ref Chris

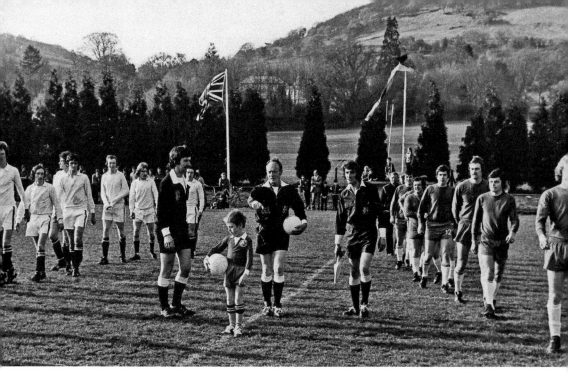

Above: Two countries take to the pitch at Pen-y-Pound.

Below: The German lads getting the meet and greet from Abergavenny's Mayor Peter Williams.

Aber lads pose for the camera prior to a twinning fundraiser at Bailey Park.

Woodhouse, and between them the gang had all the experience and skills needed to make the Abergavenny Select/Ostringen soccer exchanges a historic success.

The very first match was played in Ostringen in the spring of 1971 for the Herman Kimmling Cup and the Abergavenny Cup. From then on the matches got bigger and better until one fateful day in 1975 when a group of Aber lads took on the giants of German football, Bayern Munich.

The match between Abergavenny Select and Bayern Munich Youth ended in favour of the most successful team in Germany's footballing history, but it was a close-run thing. And if it wasn't for the twin town football exchanges between a little patch of Monmouthshire and its Deutchland counterparts, the game between a bunch of local lads and the Bundseliga big-shots would never have happened.

Coach Terry Hodgins went along with the lads for their date with destiny and recalled telling them beforehand, 'Stay sober, watch your language, don't be a prima donna and you might even come home with a trophy.' They didn't, but as Terry admits 'The game was a testament to the benefits to local football that being a twin town had triggered.'

P

Pen-y-Pound – They Call Them the Thursdays

Although their name is no more, the spirt of the Abergavenny Thursdays lives on at the hallowed turf of Pen-y-Pound, where Abergavenny Town continue to fly the flag for the teams of yesteryear who used to turn heads at the Welsh Wembley.

The Abergavenny Thursdays started life during the 1890s under the banner of the Abergavenny Rangers. The club became Abergavenny Thursdays in 1927. The name represented the fact that many of the players worked in shops and factories, and Thursdays, being half-days, were the best time for the club to organise games. Their matches were initially played in Bailey Park, but sometime during the 1930s games were moved to the Pen-y-Pound ground – hence their nickname 'the Pennies'.

The Thursdays sitting pretty in the 1950s.

The Thursdays way back when.

Led by local businessman Vince Sullivan, the first management committee initiated grandstand and supporting facilities in the form of a 250-seat stand and clubhouse. The Thursdays were crowned Welsh League champions for the first time in 1959 and won successive titles in 1991 and 1992 before the formation of the new League of Wales (now known as the Welsh Premier League) for the 1992/93 season. They could have secured a place in the European Cup if they repeated their 1992 success in the League of Wales first season, but circumstances dictated otherwise.

Regulation reared its ugly head and subsequent seasons were not kind to the Thursdays, who slipped through all three divisions of the Welsh League before finally ending up in Division Three of the Gwent County League. In the course of five seasons, the once mighty Abergavenny Thursdays suffered four relegations and conceded 675 league goals.

Things came to a head in the 2013/14 season when they made the shock decision to not field a team in the Gwent County League and allow Govilon AFC the full use of Pen-y-Pound for all of their home games. At the time Thursdays Trustee Ray Warren explained, 'It might well be that at some point in the future the name Abergavenny Thursdays will be consigned to an honours board and from my own personal point of view that would be devastating because my family and I have an association going back 75 years with this club.'

After just one season, Govilon became Abergavenny Town and the Abergavenny Thursdays were consigned to history – but what a history.

Perhaps one of the Thursdays' greatest players was Brian Evans. Brian played for Abergavenny Thursdays for three seasons between 1960 and 1963. He transferred to

The life of Brian: the former Thursdays player in his Hereford United strip and at Bailey Park signing autographs for the fans.

Swansea City in 1963 for the sum of £650 where he made 356 appearances, scored fifty-eight goals and won five caps for Wales. He played for the Swans in the old second, third and fourth divisions of the football league.

In June 1973 he transferred to Hereford United for a fee of £6,000, where he made forty-eight appearances and scored nine goals. He is still treated as a 'legend' at Hereford as he is the only player to win caps for his country while at the club. He is also renowned for playing in the 9 January 1974 FA Cup victory over the great West Ham United team, where he famously supplied the assist for Alan Jones to score the winning goal for Hereford.

Local football fan Rob Hurley remembers a very interesting chapter in the Thursdays' history regarding a football match that took place on 4 April 1976 between Hereford United and the team:

> Hereford United were about to be crowned Third Division Champions in a few weeks and were busy acquiring quality players for their forthcoming assault on the old Second Division or Championship league as it is known today.
>
> The Hereford United team included Tommy Hughes a former goalkeeper for Scotland, Chris Price who later signed for Blackburn Rovers and played alongside

Strike! A shot from the season on when Govilon played out of Pen-y-Pound.

Alan Shearer in the team that finished second and fourth in the Premier League and Kevin Sheedy, who was in Everton's title winning teams of 1985 and 87, and in 1985 scored in the final of the European Cup Winners Cup.

Kevin also played 46 times for The Republic of Ireland scoring nine goals, including one in a game in the 1990 World Cup against England.

I know what you are thinking, why the long build up? Well, Abergavenny won the match 2-1!

Of course, perhaps the most famous feet to grace the historic turf of Pen-y-Pound belonged to John Lennon. The scouse songbird landed there by helicopter when the Beatles played the Town Hall in 1963.

Quaint Abergavenny – The Marvels of Modernisation

It's big, it's bold and it's been capturing the wandering eye and gossiping tongue of many an Abergavenny native with its whiter than white demeanour and curiously cubist style. It is, of course, the mighty monument to modernism that is the new Morrisons superstore.

The pale and imposing monolith officially opened its doors and invited Abergavenny in this year and its curious design has courted more attention than a fluorescent chicken in a field full of foxes.

It's been a long time coming, but the eagle has finally landed. For better or worse, Abergavenny's new cathedral to commerce is set to become as much a part of the town's landscape as the Town Hall, the castle and the Angel Hotel. And no matter if you regard it as a blot, a blight, a boon, or a benefit, it's safe to say the newest shack in town doesn't look exactly how we were led to believe it would. The newest and whitest box in Abergavenny has been branded an eyesore, a modern monstrosity, a testament to abject ugliness, a frightful fancy and a big bloody mistake.

Almost all are in accord that it does nothing to enhance the historic town's landscape or improve the quality of the environment. They remain puzzled how the council's planning department allowed such a design to be built in a town that only a short time ago hosted the National Eisteddfod.

The old home town don't look the same.

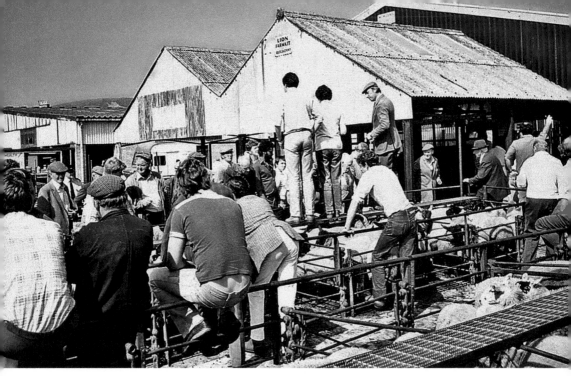

When the site of the supermarket was a cattle market.

Independently run shops have always been integral to a town's identity and were renowned for fostering a community spirit in a way that the sterile shacks of consumerism and torrid tombs of transaction that call themselves 'supermarkets' cannot. Once a mainstay of UK high streets, small independently run shops have vanished in huge numbers from towns across the country. But in losing them, have we also lost the traditional values that so defined society during their prime?

When author John Barnie was growing up in Abergavenny in the 1940s almost all the families he knew ran shops. And it is this way of life that is captured so vividly in the evocative account of E. C. Barnie, wholesale and retail confectioner. In his book *Tales of the Shopocracy*, John Barnie looked back over his father's life as a small-town shopkeeper, painting a portrait of a world where you worked hard to 'get on', where waste was a sin and debt was frowned upon. A world of churchgoing, caution and respectability, and where gardening, home cooking and the Empire were revered. In short, Ted Barnie lived in a world long lost to many modern readers, but it is also a world that will be remembered – and maybe missed – by a whole generation.

John Barnie was determined to make a record of this time for the benefit of his son, as the author explained,

> Our son was born a year to the day of my father's death, so my wife suggested I write a few things down about the granddad my child would never know.
>
> The book was born from there, and became an attempt on my behalf to evoke my father's attitude towards the world he lived in. And as he was a shopkeeper, his attitude was very much part and parcel of his profession.

In an economic and engaging style, *Tales of the Shopocracy* vividly captures a much different and smaller Abergavenny to the one we know today, as Barnie points out:

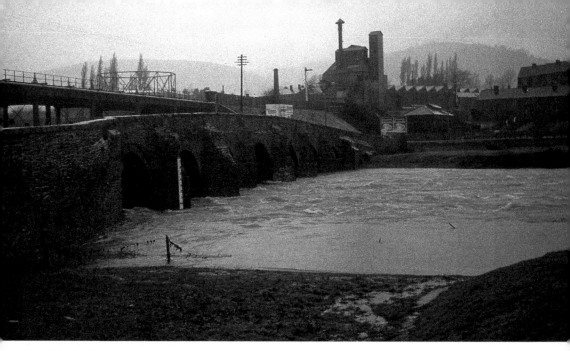

A bridge from the present to the past.

My father was born into a world of horse transport where an automobile still had to have a man with a red flag walking before it. Yet by the end of his life the roads were choked with cars, aeroplanes flew at supersonic speeds across the Atlantic, and the Americans had landed on the Moon.

My father was part of the dilemma of a prosperous mass society in a way that he, like many others, never understood or come to terms with. Car ownership was an evident good which is why he bought one, but when car ownership spread, it became less good.

The balance between the quiet small-town world he had grown up with and was at home in, and the process of modernisation which he had quickly embraced, became more difficult to maintain until the end of his life in the 1970s, it was destroyed.

In a sense you could view the 'Shopocracy', albeit in subtle way, as protagonists of their own downfall, as rampant and unchecked capitalism charted a course to its logical conclusion of monopolies and brand culture.

Yet, as Barnie mentions in his book, 'There is a dividing line between being a shopkeeper and being an entrepreneur and my father's generation never crossed it. The skills and experience needed to run a sweet shop are different from those needed to run a tobacconist.'

Although it depicts a time that will never come again, Barnie's memoir is far from shadowed in the rosy hue of nostalgia and highlights his own rebellion against the small town mentality that would have him conform. In hindsight, he is quick to admit that it was 'done in the crude and sometimes brutal way of teenagers', attacking his parent's core beliefs like a 'terrier with a rag doll'.

Yet, his was always a rejection of their beliefs and never of the people he loved. He admits in the book that when teaching for thirteen years in Copenhagen 'Abergavenny and the borders were always on my mind. For some time I had a tuft of sheep's wool picked up in the Black Mountains, which I would hold to my nose now and then for its

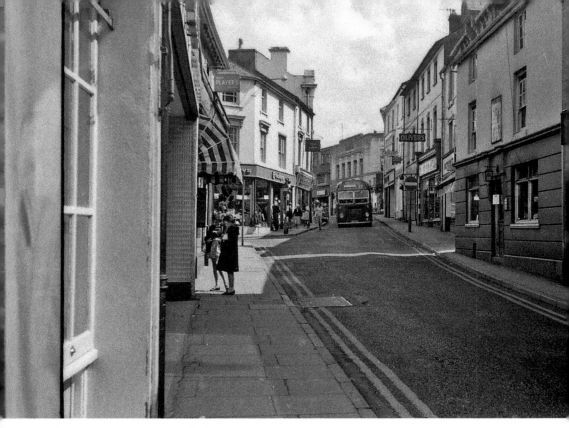

Above: A snapshot from way back when.

Below: A stone feature in Bailey Park commemorating the Abergavenny Livestock Market.

muttony smell and which, along with the aroma of a frond of bracken crushed in the hand, is the smell of the border hills to me'.

In a time where waste was a sin, the era of the 'Shopocracy' was much less damaging to the environment than the disposable 'chuck it and bin it' mentality of today, which leads to the question: was their existence more beneficial to the community than the anonymous superstores of today? 'I think so, yes,' answered Barnie. He added:

> Small shops keep towns alive and help contribute towards the town's identity and character.
>
> You talk to the old shopkeepers and they are full of stories about the town and its history you will not find anywhere else, because they played such a defining role within the community. They are the human face of shopping that cannot really be found over the counter in a superstore.
>
> I think in amongst the gloss and sheen of modern shopping centres, we are in danger of losing our identity somewhat. It is hard to find a human dimension in the sterile and bland atmosphere of the modern mall. And personally I found it quite an ordeal shopping in such places.

For whom the bell tolls – calling time on Abergavenny market.

Racetracks and Riots

Nowadays the only races you find in Abergavenny on a regular basis are those involving two wheels and a lot of Lycra, but between the heady days of 1860 and 1880 the Gateway to Wales was considered to be one of the best meeting grounds for horse racing in many a mile.

At Abergavenny, five furlong races were sandwiched between steeplechases and hurdle races, and in 1872 the town was home to the National Hunt Chase. The once famous racetrack, which now lies buried beneath the eighteen holes of the Monmouthshire Golf Club, saw Red Nob romp home by two lengths on a bright spring Thursday morning in April 1872.

It wasn't just Abergavenny where the gees gees were all the rage, though: both Brecon and Monmouth held horse races frequently, albeit rather flat ones with the odd hurdle thrown in. Then, as of now, horse racing attracted its fair share of colourful characters. One of them was master of the Monmouthshire Foxhounds, Reginald Herbert of Clytha, who was described as 'a fanatical follower of the turf.'

Renowned as polo pioneer, intrepid gambler and absolute spendthrift, Herbert also owned his own racehorse, and as a gentleman jockey, enjoyed plenty of success on it.

Herbert's trainer was another interesting gentleman, who went by the memorable name of Fothergill 'Fog' Rowlands. Fog's father was a doctor at Nantyglo Ironworks and although our Fog also became a man of medicine, his heart belonged to the races and his wallet to the bookies.

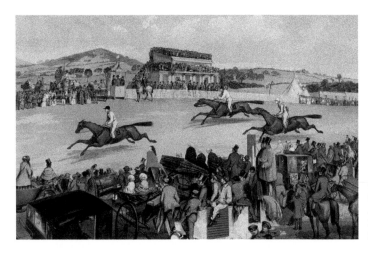

Left and opposite: Scenes from the days when Abergavenny was renowned far and wide for its horse racing meets.

Perhaps one of the most memorable races Fog had a hand in was the notorious Monnow Street dash. The legend goes that after a fine dinner of mutton and ale, for a bet Fog decided to race his fellow diners 50 yards up Monmouth's famous street, carrying Reginald Herbert as a handicap. Fog won by half a length as he stumbled over the finish line and sent poor old Herbert shooting over his head.

Of course, there was none stranger in the topsy-turvy world of local racing than the dwarf known affectionately as 'Little Dyke'. Little Dyke was the clerk of the course at

Monmouth and always wore a top hat to make himself appear taller than his 3 feet and 6 inches would suggest. Although diminutive in stature, he had no qualms about standing up for himself. He once famously got into a bit of a quarrel with the then well-known owner Epsom. Why? Because Little Dyke believed Epsom had cast an outrageous slur upon his honour. So he subsequently challenged him to a duel.

Lord Jersey was a mutual friend of the argumentative pair and, not wishing to see either come to any harm, insisted that instead of guns or sword, their duelling weapon of choice should be none other than their tongues. Intrigued by such a fantastical notion, the duelling duo agreed and, much to the amusement of Monmouth racegoers, the two combatants spent a full ten minutes screaming in their opponent's face and turning the air blue with their non-stop abusive tirades.

As is only sporting, once the two had finished slinging their verbally vitriolic volleys at one another, they shook hands and the crowd roared their delight that there would be no unsightly corpses to contend with on this day.

Little Dyke ran horses under his assumed name of Adams, and in 1873 a native of Abergavenny and well-known jockey called Jack Goodwin was involved in a controversial romp on one of the Monmouth dwarf's mounts. (More of which later, folks!)

At the time, Goodwin's father was the landlord of the town's Swan Hotel, and the popular publican was involved in an unusual equestrian type tale of his own, which is worth retelling here for the price of a pint.

The story goes that it was a blustery and ferociously foul night in Abergavenny when Father Ignatius of the newly built Llanthony Abbey burst through the doors of the Swan like a messenger straight out of the pages of the Old Testament. Dripping from head to toe in a rain-soaked monastic carb and shrouded in a heavy air of righteousness, Father Ignatius struck an imposing figure to the gin addled regulars in the Swan. However, on that night, the holy man's mission in this particular drinking den wasn't to save sinners but to commission a cart to take him to Llanthony.

The regular driver was unfortunately bed-bound with a fever, so Goodwin volunteered to drive the man he called 'the Abbot' back to Capel-y-Ffin. On such a dark and desolate night, the only ride on offer was a decrepit nag and a ramshackle coach, but beggars or men of the cloth can't be choosers. And so it came to pass that Father Ignatius and Goodwin Snr, who was fortified against the elements by half a bottle of rum, set off from Cross Street into that hellish night. Roads that were poor at the best of times had now become harder to navigate as they streamed with water. Swearing at the storm like a sailor at sea, Goodwin continued to plough on, but coming to the end of both his endurance and his wit, the landlord came to the grim conclusion that, holy or not, his passenger was going to have buckle down and put his back into it if they were going to get to Capel-y-Fin intact. Goodwin bellowed, 'Tumble out your holiness and put your shoulder to the wheel.' And so, with his skirts pulled high, Father Ignatius pushed the man he'd paid to pull him to shelter and safety.

Now let us return to the Swan landlord's son, Jack. In the immediate aftermath of a certain race in 1873 where many locals lost significant bets after backing Goodwin to win, rumours began to circulate that the hapless jockey had lost on purpose. After the race many a disappointed gambler surrounded Jack and his mount as they headed to the weighing room. With his horse lashing out in panic and keeping the angry

punters at bay, a running fight was made back to the enclosure. Goodwin vanished into the weighing room, out of the racetrack, into the street, and away. The mob however, were just getting warmed up.

Surging around a bench on which the Duke of Beaufort was sat with some friends, the commotion went from bad to worse, as our old friend Reginald Herbert, who was present, recalled at the time:

> Over went the bench, over went the Duke - His Grace, Josey Little (who fought like a Trojan) and sundry others, all struggling on the ground together. The Duke really seemed to enjoy the situation as he picked himself up, and, our forces rallying, we began steadily to drive back the now somewhat discomforted rioters.
>
> The uproar still continued, and I could see Little Dyke who, being badly adapted to a rough-and-tumble of any sort, had managed to scramble up into the grandstand, waving his arms, while screaming at the top of his shrill falsetto voice, 'Save the Dook, gentlemen, for Gawd's sake, save the Dook!'

The occasional mounted maverick can still be spotted on the streets of Aber.

For the most part you'll find an altogether different form of racing in modern Abergavenny.

Swimming Pool – Paradise Lost

There's something eternally intoxicating about swimming in the great outdoors beneath skies of blue on a lazy summer's day. And there's no pool like an old pool.

All those who sampled the rare delights to be found in the refreshingly cool waters of Bailey Park swimming pool will remember fondly how popular Abergavenny's watery paradise once was: filled with those who liked to take a dip when the sun burned bright and the temperatures soared like a solar flare. Sadly, the pool closed its doors for the last time in 1996 due to health and safety issues and a lack of funding. In April 2006, Monmouthshire County Council decided to fill in the main pool and the adjoining learner pool for fears of vandalism.

The pool, which once held 162,000 gallons of water, and was opened by Mayor W. Rosser in April 1940, was no more. Now only grass remains and one or two of the original walls, which still stand in mute testimony to Abergavenny's aquatic adventures.

Interestingly, Swan Meadow was once considered a possible site for an outdoor swimming pool, before the town council opted for Bailey Park. The pool was built for the princely sum of £6,500.

There's a new campaign gathering momentum on the streets of Abergavenny to not so much reopen the Bailey Park pool – you can't, as all that remains is a patch of rather unassuming grass – but to build a brand new state-of-the-art Lido.

It's a big task, but the longest journey begins with the smallest steps, and who knows, if the right people in the right places pull a fair few strokes, anything's possible. Celebrities such as Michael Sheen, Owen Sheers, Derek Brockway and Matthew Pritchard have backed the campaign, which is making a splash in all the right places, except in the darkened corridors of Monmouthshire County Council. A spokesman for MCC said,

> Re-opening the pool would involve an Herculean effort, as it is no longer there. The site was demolished in 2006 and filled in and is now a fully grassed level area of the park, so any proposal to run an open air swimming pool would involve the initial costs of construction.
>
> Abergavenny's small resident population indicates that it would be difficult to write a viable business plan to underpin any proposal for large scale investment in a new pool, either in the park or in another location in the town.

Such banal practicalities are not enough to stem the tides of collective nostalgia, and the hunger for a new pool in Abergavenny remains as fierce as the July sun.

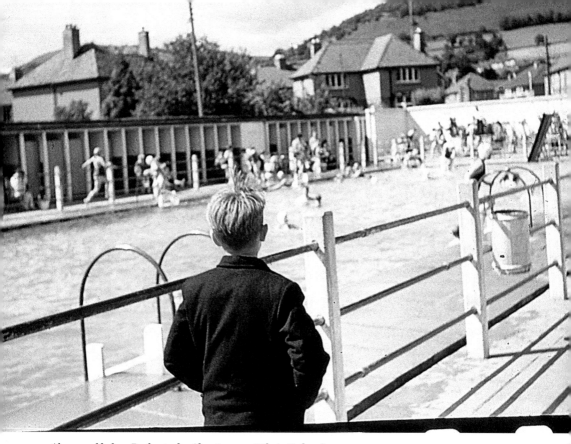

Above and below: Pool patrol – Abergavenny Lido in its heyday.

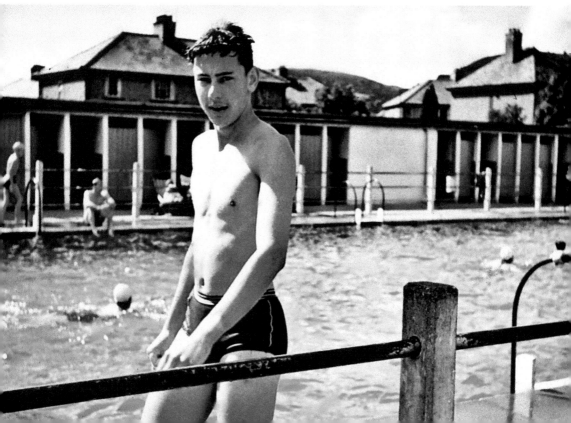

Bonita Stinchcombe (née Kirkwood) spent many a happy day at the old Bailey Park pool in the 1940s:

I was born in Abergavenny and spent many happy hours there. We lived in Park Close so all the children there had season tickets, the first one was seven shilling and sixpence the second one was twelve shilling and sixpence.

My sister and I would rush home from school and go straight over to the pool. I also went to the pool with my school come rain or shine; afterwards we would go to the cafe for hot oxo to warm us up.

I remember when they built the other two pools, one paddling pool and the other where my friends taught me to swim.

On the weekends it would be very busy they had two sessions 2pm until 4pm, the second 4pm to 6pm.

Never shy to take a long and meandering trip down memory lane to rake up the past and muddy the waters, chirpy old hack Don Chambers also has fond memories of Abergavenny's aquatic paradise and recalled:

When I became a pupil at King Henry VIII Grammar School in the 1940s, I found there was more to learning than Latin and algebra. An hour or so on one day every week during the summer we had 'swimming lessons' which meant a trip to the pool in Bailey Park to avoid drowning.

Below and opposite: Is the British weather really suitable for all-year-round outdoor bathing?

We ran like gazelles, charging down Pen-y-Fal Road and across the Fairfield to the little gate at the very end while taking off various items of clothing en route. By the time we reached the pool it was just one final 'strip tease act' and we were in the water.

The best part was not splashing ice-cold water over ourselves but plunging in before anyone else. To be first meant the title-holder for that day was revered and even looked up to, even if the 'winner' was gasping for breath and had to be pulled out.

In later years, when I became a reporter, I was invited by Mr Dyer, the pool superintendent, to watch him dive into the inviting waters - in mid-winter. With snow on the ground and ice on the pool, he cut a narrow lane from end to end. As I watched him I shuddered. I never became a strong or even an enthusiastic swimmer - but I did admire that man's courage.

Can the people of Abergavenny build a new pool and forge some new memories? The answer's uncertain, but think on this folks: you gotta have a dream if you're gonna have a dream come true.

Alison Todd – A Hat for Every Occasion

Every lady loves a hat for that big occasion, and special headwear for that special event is something Abergavenny's Alison Tod knows all about.

With a lifetime of experience in the world of couture and a host of awards to her name, Alison's colourful and creative creations have graced many a famous head, including that of the late Princess Diana.

I sincerely believe there is a hat for everybody. I often encounter people who say 'Big hats do not suit me.' I see that as a challenge for me to prove them wrong. I'm always of the opinion that someone should look good in the right big hat, rather than terrible in the wrong small hat.

When I meet people, I'm forever instinctively thinking over in my mind the right type of hat that would suit their shape and size. The process has become second-nature to me now.

When a customer visits the shop looking for the perfect hat to compliment a particular outfit, I really enjoy helping them to create that look of elegance which everybody strives for when it comes to wearing the right headwear.

A young lady models one of Alison's creations.

Alison grew up in the local area, before moving to London to carve a name for herself in the world of fashion. She returned to Abergavenny in 1991. She attributes her trailblazing trajectory – from a young hopeful studying a textiles degree in South Cheshire to an award-winning milliner who has appeared in *Vogue Italia*, won the Welsh Fashion Awards two years in a row, seen her work paraded on the catwalks of London, Paris, New York, Milan, and who has sold collections to Harrods, Simpsons of Piccadilly and Printemps of Paris – to her formative days when she was growing up with her parents in Llanfoist's Boathouse.

> I think being bought up in the countryside was a key inspiration in terms of my creativity. I've always been fascinated with colour, and where I used to live in Llanfoist was like a scene from a Monet painting. There was a bluebell forest just behind our house, wild roses out the front, and the most amazing and flamboyant giant hydrangeas that were quite rare and very difficult to grow back then. Overall the whole picturesque and life-affirming environment combined to have an effect on me that I would have missed out on growing up in the city.

Alison's love of colour, flowers and hats came to fruition when she left university and started working in London as a junior designer for the milliner's milliner and consultant design director for Kangol – Graham Smith.

Below left and right: Picturesque Abergavenny has long been an inspiration for artists and writers from far and wide.

Abergavenny by Joseph Mallord William Turner.

Working with Graham was a great experience, because it was so varied. Kangol was the largest manufacturer in Europe at the time, and as well as designing collections for Next, Debenhams, BHS, M&S and all the other leading high-street stores, we were commissioned to do a lot of one-off hats for such figureheads as Margaret Thatcher and Princess Diana, as well as the Queen's ladies-in-waiting.

Alison, who has had hats commissioned from people living on all four corners of the globe, added: 'Probably one of the most flattering experiences I have had working in the shop was when a lady from Paris ordered a hat to be sent over to France for her, because apparently she "couldn't find a nice hat in Paris". Something which is quite extraordinary when you think about it.'

U

The Usk – Old Man River

The River Usk, or as it's known in Welsh, Afon Wysg, flows through the length and breadth of Abergavenny like a thing of shimmering beauty before it ends up in Newport and discharges itself into the Severn Estuary. And, like most things that end up in that old port town, it always looks slightly soiled and a little the worse for wear after leaving leafy Monmouthshire.

The Usk is a site of Special Scientific Interest and home to a diverse range of flora and fauna. Take a jaunt alongside its banks or a paddle in its delightful depths and you'll have a good chance of bumping into otters, kingfishers, herons, red kites, twait shads, lamprey, common roaches and, of course, Atlantic salmon.

The mighty Usk during a ferocious flood.

In the Common Brittonic tongue, the Usk translates as 'abounding in fish'. And, of course, among the fly-fishing community the river has long been famed for the quality and quantity of its salmon.

In 2006, seventy-two-year-old Derek Carey definitely bagged the catch of the day when he became acquainted with a 20-lb salmon from the depths of the River Usk. The Penpergwm man, who had only been fishing for three years, lined-up, hooked and reeled in the sort of fish that even the most experienced anglers can only dream about. The watery wonder took him an endurance-testing twenty-five minutes to land in an epic encounter between man and fish, which ended with the salmon coming out on the losing side, but not before breaking Derek's £150 rod in the process.

Derek said, 'I had a friend who had been fishing for 18 years, and he jested that he'd give his right arm to catch such a salmon. It's a lifetime ambition for a lot of anglers. And that particular fish became the talk of the river for weeks after.'

Derek caught the scaly sensation at Kernys Commander with worm bait, after catching a 10 lb and seven oz salmon the previous Friday. In fact, the very next day after catching the 20 lb whopper, Derek went on to catch another 9 pounder. Derek explained the secret to his success:

It was my nephew Michael Wright who really got me into fishing. He's a fantastic fisherman and has been at it for years. I think the only secret is that when you dip your rod into the water you've got to be 100 percent focused on the line. You cannot be half-hearted about it. You've got to clear your head of all thoughts and just rely on pure instinct. That's why fishing is such a brilliant antidote to such things as stress, it's the best way I know to unwind – even more so than golf. When I first started out, if I had a salmon on the end of my line I'd often start shaking with excitement, and as a result they'd fight their way free.

With a salmon, especially the bigger ones, they will struggle fiercely for their survival, sometimes jumping out of the water and rising three foot into the air to try and shake off the line.

You've got to show a lot of upper-body strength and stay relaxed if you want to better them, and the one I caught that day was the toughest bruiser I've met to date.

Would you like chips with that sir?

Victorian Abergavenny

Like relics of a bygone age, Victorian architecture, institutions and industry are still visible in Britain's towns and cities. Abergavenny is no exception. Its buildings, houses and streets run riot with ghosts from an age where great wealth walked hand in hand with abject poverty, where the misery of child labour supported idle gentlemen of leisure, and where cruelties and degradations of every form were hidden by the velvet cloak of hypocrisy.

Yet, when you lift the lid off the sewer and take a peek behind the strait-laced curtains of the standard textbook history into the murk and mist off an oft-forgotten world, you'll find gaslit streets swarming with filth, fighting and fornication. A place where murder was rife, brothels were commonplace and children were sent to prison for stealing fruit or playing football. The 'standards' of that hypocritical age may have long been laid to waste by the plastic sword of modernity, but the tales of those who led the charge in the name of enterprise and imperialism is all there waiting to be discovered, sitting snugly between the black and white lines of old newspaper copy.

The *Abergavenny Chronicle* from the Victorian era abounds with tales of poor folk condemned to the picturesque Pen-y-Val asylum for 'moral insanity'. This was an umbrella term that included women with postnatal depression, alcoholics, unfortunates prone to melancholy moods, and even those who people thought were just a bit odd.

The sprawl of Pen-y-Fal from the skies.

If you escaped the clutches of the 'madhouse' you might be doomed to the drudgery and grind of the workhouse. Of course, if you were really pushed to make ends meet and resorted to stealing some bread and cheese just to fill an empty belly, you could end up being sentenced to ten days hard labour and three years at Little Mill Reformatory, as was the case of twelve-year-old Richard Reed in 1871. Being 'banged up' for stealing the most inconsequential items was commonplace in the Victorian era, where the few prospered through the poverty of the many.

Between 1841 and 1901 the UK's population soared from 27 million to 41 million as social inequality became more marked and entrenched. Industrialisation, personified incarnate in this neck of the woods by the Crawshay Bailey family, was one of extremes. On one side of the coin there was innovative engineering, affluent development and civic pride; on the other, overcrowded slums, abject poverty and premature deaths.

On 22 January 1901, the figurehead of the Victorian era, Queen Victoria, died. Reporting on the funeral of the monarch, the *Chronicle* wrote, 'Saturday, February 2, 1901, will long be remembered by the people of Abergavenny as a day of deep mourning. The line of route, down Cross-Street and Monk Street to St Mary's were densely crowded with people, all in mourning. All blinds were down and the bells of St Mary's rang a muffled peal.'

The queen was dead and her demise would usher in a new dawn: the twentieth century. Interestingly, on the same day the queen died another person of interest was found dead in Abergavenny. Lying lifeless in a Flannel Street doorway, passers-by discovered a local tramp. They were shocked to discover that within the lining of his threadbare coat there lay concealed the small fortune of 600 English pounds. It certainly is a funny old world!

Down the ages for a stroll along Brecon Road.

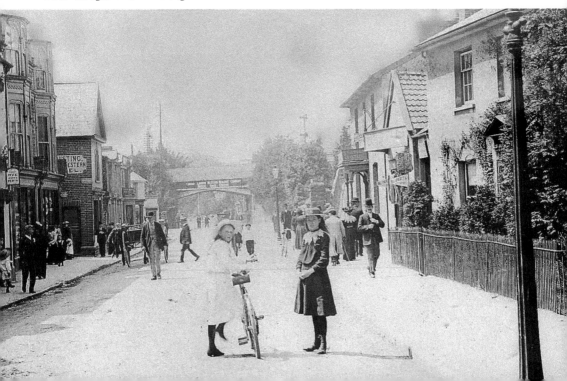

W

The Workhouse – An Abergavenny Institution

In Victorian times if you were poor, desperate, orphaned, work-shy, old, infirm, or an unmarried mum or a gentleman of the road, then chances are you'd serve a stint in the repugnant environment and brutal conditions of the workhouse. Although originally intended to be a deterrent to the able-bodied pauper, the workhouses soon became a place where society could dump any undesirable.

The Abergavenny Poor Law Union was established on 8 May 1837. The Abergavenny Union workhouse was built in 1837–38 and could house up to 150 inmates. It's no secret that the Union Workhouse and Pen-y-Fal were once the two largest building complexes in Abergavenny. There must have been an awful lot of people the great and good of Abergavenny didn't want souring the streets. If the establishment perceived you as undesirable and couldn't brand you insane, they'd brand you as work-shy and off you'd go to one institution or another, without recourse or relief.

The workhouse of today still carries an imposing air.

The workhouse was all about degradation. If an able-bodied man entered its doors, his whole family would be dragged along with him to suffer its harsh regime and spartan sadism. Men, women and children were housed separately and lived of a diet of gruel, bread and cheese.

In the late 1800s the Guardians of the Abergavenny Union asked, 'By what means can the reduction of the number of vagrants that seek nightly relief in our workhouse be most effectively accomplished?' In a damming report, they went on to state:

> The increase of the number of tramps is well-nigh alarming. The ranks of vagrancy are with few exceptions, composed of idlers, wastrels, thieves, and the lowest dregs of society, and from these ranks the lists of permanent paupers are very largely recruited. If the career of 90 out of every 100 professional vagabonds were traced, it would be found that their lives, spent in indolence and crime, ended in the workhouse. The number of vagrants which invaded Abergavenny daily is becoming a nuisance, of which the ratepayers ought to be relieved. The business of the tramp must be made as distasteful as possible.

In other words, any vagrant cheeky enough to pass through Abergavenny was to be forced to labour in the workhouse for the good of the town. Or, to speak plainly, the coffers of the wealthy were to be given a timely boost by an army of paupers.

The workhouse wasn't a prison in theory, but it didn't always work like that. Take Thomas Price, for example: it was reported that he was an 'absconding pauper' who

For many the only way out of the workhouse was in a coffin.

had fled the workhouse with a suit of clothes. Needless to say he didn't get far before the authorities hauled him back. And then there was Ellen Bevan, an inmate who was charged with taking three blankets without first asking the guardians. That little misdemeanour cost her one month in prison with hard labour.

Apparently it wasn't all bad in the Abergavenny workhouse, though. On Christmas Day, by the order of the guardians, the inmates were allowed roast beef and plum pudding. And after 'each person had partaken of the good things provided without any stint,' the men were supplied with an ounce of tobacco and a pint of beer and the women received an ounce of tea and half a pound of sugar. Meanwhile, the children were given oranges.

The workhouse can still be seen in Abergavenny today, a stark reminder of how the Victorians, like many in the modern world, didn't really believe poverty was an issue to be addressed, but instead thought that being poor was inevitable for large swathes of the population. As Patrick Colquhoun wrote in 1806:

> Poverty is a most necessary and indispensable ingredient in society, without which nations and communities could not exist in a state of civilisation. It is the lot of man – it is the source of wealth, since without poverty there would be no labour, and without labour there could be no riches, no refinement, no comfort, and no benefit to those who may be possessed of wealth.

X Division – The Abergavenny Underclass

In the Victorian dictionary of crime, the 'X Division' was used to describe the part of society that was made up of crooks, thieves and criminals – think Bill Sykes and Fagan and you're on the right track. In Abergavenny, crime was nowhere near as rife as the old East End of London, but getting into bother with the law was a lot easier in Victorian times when law and order was enforced with a cast-iron will. Pinching pears, for example, could land you in hot water, as it did two six-year-old lads named George Owen and George Yapp. The two fruit-loving youngsters appeared before the bench but fortunately on that occasion escaped a custodial sentence.

Deserting your wife was no laughing matter either. Chair mender Jeremiah Madden did just that and was sent to prison for a fortnight to think on the error of his ways.

Sleeping in the open air was also an offence of some gravitas, as Sarah Jones found out. Apparently the lady in question had been leading a 'questionable life' for around six weeks, when she was charged with being asleep in a field near the turnpike on the

Visions of old Abergavenny.

Brecon Road beneath the trees. The case against her was dismissed on her promise she would leave the town.

Being drunk and disorderly was no joke either, especially being intoxicated in charge of a horse, as William Prosser found out when he was thrown into the nick for a week.

Naturally, keeping a brothel was a no go under Section Six of the Abergavenny Improvement Act 1871. James Flynn of Ireland Street appeared before the magistrates with keeping a house of ill repute, but the case against him was dismissed because of lack of evidence. Brothels in Ireland Street were apparently all the rage as one Issac Jones was also charged with keeping one.

Knocking on someone's door and running away was enough to get you banged up for at least a day, as young Thomas Murphy found out after knocking up Mary Ann Fairchild of Tudor Street.

For stealing eggs, twelve-year-old William Lloyd was sentenced to six strikes of the birch and Thomas Watkins was given one month of hard labour for begging in Llanfoist.

In the Victorian era, where the Deri View School now stands, there was a notorious lodging house, which the *Chronicle* at the time reported was, 'The resort of perhaps as mixed a lot of nomads as any to be found in the country. It was in fact the principal house of call for travellers of the casual class in the town, and it was always crowded to such an extent that it was a source of constant anxiety to the police. Disputes among guests, who were of many nationalities, were of frequent occurrence and as they were often enforced by means of any weapon that might be handy of a more or less lethal kind, the interference of police was frequently required'.

Like with any underworld, Abergavenny's X Division had their own lingo, and it consisted of a list of words that were once widely used in Monmouthshire and Herefordshire. See how many you recognise:

Winicky child – a weakling.
Nisquel – the small piglet of a litter.
Stoggle oak – a stunted, misshapen oak.
Snowl of food – a little food taken to work and eaten on the job.
Ascal – either a stoat or a weasel.
'I'll hone you' – 'I'll beat you up' (or sharpen you up).
Knap – to strike (as in 'I'll knap thee')
Argy – a pole acting as a fence across a stream.
Costrel – a small barrel-shaped wooden vessel.
Carron – someone or something foul or worthless.
To drash – to trim a hedge.
Pishty – a puppy or a small animal.
Tup – male sheep.
Peart – sharp or keen.
Market peart – a person who has had one over the eight.
Puthering about – not working to any useful purpose.

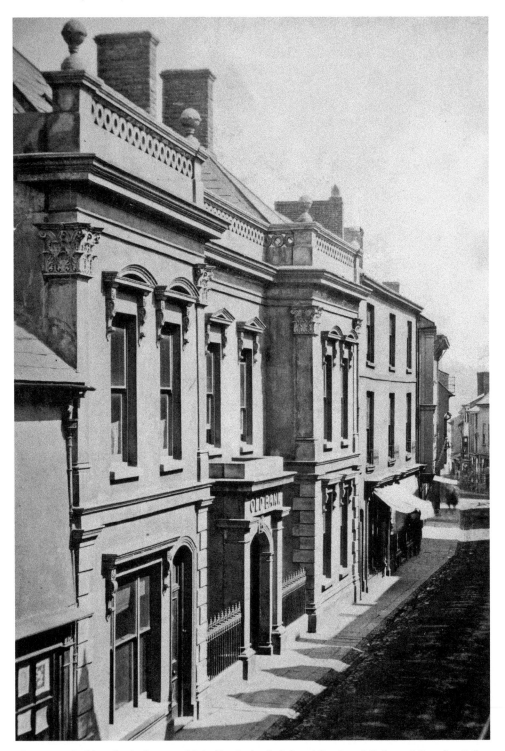

Abergavenny's Old Bank, which was established in 1837 by the industrialists Joseph Bailey and Crawshay Bailey.

Y

Bryn Yemm – The Boy from Tudor Street

Abergavenny's Tudor Street, as it was once known, is no more. Its Elizabethan architecture, rough-and-ready charm, tight-knit community and dimly lit drinking dens have long been destroyed by the swing of the wrecking ball. In its place there lies little to remind visitors of how different this little corner of Abergavenny used to be. Yet the old street still lives on in the hearts and minds of those who once lived there.

Bryn Yemm is perhaps Tudor Street's most famous son. And the man dubbed the 'most famous unknown singer in Britain' has got a lot to thank the old neighbourhood for. Bryn's biological mother, who was Italian, gave birth to him in the town whose name he carries: Brynmawr. Struggling to cope with the young child, she made the decision to take him to the children's home in Cardiff. Here's where fate intervened. Standing at the Brynmawr bus station, the mother was approached by a lady who told her that Mary and Ivor Yemm in Tudor Street, Abergavenny, wold look after Bryn better than any children's home could.

A mere hour later, Bryn arrived at the door to No. 66 Tudor Street and was given to his new family. Bryn explained, 'I was blessed to be from an adopted family, and even more blessed that they were a Salvation Army family.' Listening to the Salvation Army Band every Sunday became a real blessing for Bryn because it's where he first developed his love of all things musical.

Here's Bryn!

Bryn kneeling next to Ringo Starr in the front row when the Beatles played Abergavenny.

When the Beatles played the Town Hall on 23 June 1963, Bryn, who was already a well-known local entertainer in his own right, was there, rubbing shoulders with John, Paul, George, and Ringo. Being in the presence of the Fab Four gave Bryn an added impetus to one day make a name for himself in the world outside Abergavenny.

The songbird laid down his first track, 'Jubilee Party', in 1977 at Rockfield Studios. The record sold like hot cakes out of the back of Bryn's motor. Bryn's big break soon followed when Woolworths, which once had 1,500 stores nationwide asked him to make guest appearances in shop. Bryn would turn up at the stores and sing his heart out and make thousands of pounds over a few days through record sales.

Bryn spent a large part of his career singing on cruise ships. He sung to thousands of peoples as they travelled the Mediterranean and made many lifelong fans in the process. Since 2003 Bryn has set up home in Port Canaveral, Florida, where he does a lot fundraising for the children's charity Variety.

Bryn, who still maintains a home in Abergavenny, spends a large part of the year here because the old town still holds so many memories for him. He explained, 'When I was 13 my mother died from cancer at 40 years of age, and I remember it very well. She passed away in the middle room of the Cow Inn in Abergavenny. Whenever I walk by I always stop, pause, look up, remember my mother and go about my business.'

Bryn also has fond memories of a little blonde-haired girl with green eyes who lived at No. 1 Tudor Street. Her name was Ann, and Bryn would one day make her his wife. In 2016 the pair performed onstage at Abergavenny's Borough Theatre to raise funds for the forthcoming Eisteddfod. Playing an 'in memoriam' piece for his daughter Tina, who they lost to cancer in March 2014, was a very moving experience for Bryn, who had come full circle and was back in his hometown singing not just for his daughter, but in his own words, 'for all the people I grew up with that have sadly passed away'.

Z

Zachariah Wheatley – The Mayoral Maverick

When the long-awaited London 2012 Olympic Games finally rolled around it was the third time in just over a century that the capital has hosted them. Of course, when the Fourth Olympiad was staged in London during 1908 it was a lot different to the sleek, slick and multibillion-pound extravaganza of London 2012.

The 1908 Olympics were hosted by London at the last minute after Italy were forced to pull out because of the damage wrought by the eruption of Vesuvius – which, incidentally, was a volcano and not an overpaid star athlete prone to violent tantrums. It's quite staggering to think that compared with the costly errors, overspend and extended deadlines of London 2012, that 100 years ago the British Olympic Association were given just ten months to locate a site, erect a stadium and organise all the necessary finance for the Olympiad.

Rewind 100 years and the Olympian standard of Edwardian times was a lot different to the one we know today. For example, in the long-running 1908 Olympics, which ran from the end of April until late October, tug of war was an Olympic event; there was no Olympic torch (that tradition began in 1928); it made an official profit of £21,3777; out of the 1,971 participants, only thirty-seven were women; diving and field hockey made their Olympic debuts; and it was the first and last time that Britain ever topped an Olympic medal table with an impressive fifty-six golds. Oh, and an Abergavenny mayor by the name of Zachariah Wheatley was selected by the Olympic committee to be one of the officials.

The Italian Dorando Pietri, on the verge of collapse, crosses the finish line in the London 1908 marathon.

Zachariah Wheatley, Mayor of Abergavenny from 1914 to 1918, was also the 'energetic secretary' of the Abergavenny Amateur Athletic Association – or the four A's as they were more commonly known.

In an edition of the *Abergavenny Chronicle* from 1908 it is reported that during the town council's annual outing to Paddington, the mayor of the time, Mr Samuel Deverall, proposed a toast to the four A's and boldly stated over a few after dinner drinks or two that Abergavenny had good reason to be proud of their Athletics Association. The mayor exclaimed that he had come into contact with such associations before but never one that possessed such vigour. Consequently, in the field of athletics, Abergavenny played second fiddle to no town, thanks to the association's secretary, Mr Zachariah Wheatley.

The mayor goes on to reveal the exciting news that Mr Wheatley has received the honour of being asked to officiate at the forthcoming Olympic games. He then explains at great length what an office of honour it is for any man to be picked for such a role, especially an Abergaverian.

It transpires during the course of the perpetual toasting and speeches, which were so beloved of the town council at the time, that Mr Wheatley was the only man in Monmouthshire who had been so honoured. Just before Mr Wheatley was due to step up to the plate and make a speech, Mr Edgar Straker quickly and enthusiastically jumped up to simply state he endorsed the remarks of the previous speakers before sitting down again.

Mr Wheatley said it was a great honour to be chosen as one of the officials of the Olympic games and thanked everyone for their kind remarks, but he was very aware that if the four A's had not been in existence he would not have been picked. He humbly added that if it was the desire of the Athletics Association, he would attend the Olympics as the representative of Abergavenny. The chairman of the association, a Mr F. Lowe, shouted, 'Go! Go!' To which Mr Zachariah replied he would do, to great applause, and the rest as they say, is history.

The First Citizen.

Yet, history has bestowed a dubious notoriety on the way the 1908 Olympics was officiated because of a legacy of dubious decisions and far from impartial refereeing. The games were tainted by unsporting conduct to such a degree they prompted the standardisation of track and field rules at future Olympics and the future selection of judges from different countries rather than just the host nation.

The most famous case of 'gamesmanship' was perhaps that of Italy's Dorando Pietri in the marathon event. After the firm favourite Canadian Aborigine Tom Longboat collapsed after 19 miles, perhaps a direct cause of the champagne his assistants gave him en route, the diminutive Italian confectioner, aided and abetted only by the odd nip of brandy to steady his nerve and clear his head, led the pack and looked certain to take the race.

Heat, exhaustion and quite possibly, intoxication, all conspired to make Pietri collapse five times and run the wrong way in the final stages. Quite literally dead on his feet, he was eventually helped first over the finish line by a gang of helpful officials and, as some quarters even suggest, Sherlock Holmes author Sir Conan Doyle.

The poor Italian was then instantly disqualified for cheating and the gold went to the American Johnny Hayes. He may have lost the medal, but he bagged the glory, and Pietri's exploits were celebrated with a special trophy from Queen Alexandria and a street in London's White City called Dorando Close was named after him.

The Olympic Torch making its way through Abergavenny on its route to London 2012.

Further controversy ensued when Birt Johnny Douglas won the middleweight boxing gold after a split decision was called by the fight's ref – Douglas's own father!

Cynics may argue that the reason Britain won so many medals was because of a host of incidents encapsulated in the story of the 400 m final. American John Carpenter won the event fair and square but he was later disqualified by British officials. The reason? Apparently it was for impeding Britain's Wyndham Halswelle. A rerun was ordered, but the three Americans refused to take part, so Halswelle ran unopposed to take gold in the only unchallenged walkover in Olympic history. Sadly, Wyndham Halswelle was killed by a sniper at the Battle of Nueve Chapelle during the First World War.

Despite all the sporting scandals surrounding the 1908 Olympics, Mr Zachariah Wheatley conducted himself with all the professional decorum and sporting dignity as befits an Abergavenny mayor and athlete. In fact, he was knighted and made Sir Zachariah Wheatley in 1920 for his services to the town.

Such was Zachariah's zeal for all things Olympic, even in his twilight years he wrote to the organisers of the Olympic Games when they returned to London in 1948 asking if he could be involved in some capacity. When the Olympic officials turned up at old Zachariah's home to talk things over, they found the old athlete bedridden and obviously unable to take part in the coming competition. However they did have a pleasant and illuminating chat with the Abergavenny sportsman about his involvement in the 1908 Olympics.

No doubt when the Olympic torch passed through Abergavenny in May 2012 it gave a slight flicker of recognition in honour one of the town's favoured sons who did his own little bit to help keep the famous flame burning bright down the years and through the centuries.

All roads don't lead to Abergavenny, but the River Usk certainly does.